IMAGES
of America

CALHOUN

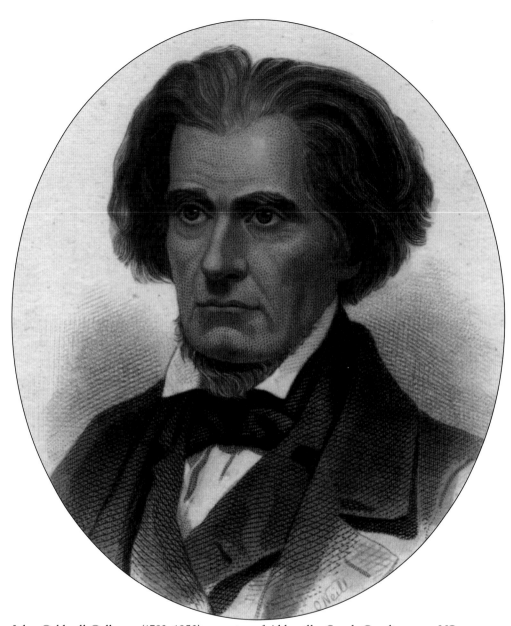

John Caldwell Calhoun (1782–1850), a native of Abbeville, South Carolina, was US secretary of war, secretary of state, a US senator, and vice president, but his presidential ambitions were thwarted by Andrew Jackson. He helped delay the Civil War by supporting the Compromise of 1850, only two years before the town of Calhoun was founded. To his death, he supported states' rights and slavery. (Courtesy of the Gordon County Historical Society.)

ON THE COVER: The Silver Cornet Band prepares for an Independence Day celebration in front of the Gordon County Courthouse in 1898. Built in 1889 to replace a structure destroyed by cyclone and fire, the old courthouse stood in the center of Calhoun until its demolition in 1961. (Courtesy of the Gordon County Historical Society.)

IMAGES
of America

CALHOUN

Jane Powers Weldon
with James W. Lay and Dale Lowman

ARCADIA
PUBLISHING

Copyright © 2015 by Jane Powers Weldon with James W. Lay and Dale Lowman
ISBN 978-1-4671-1358-8

Published by Arcadia Publishing
Charleston, South Carolina

Printed in the United States of America

Library of Congress Control Number: 2014948589

For all general information, please contact Arcadia Publishing:
Telephone 843-853-2070
Fax 843-853-0044
E-mail sales@arcadiapublishing.com
For customer service and orders:
Toll-Free 1-888-313-2665

Visit us on the Internet at www.arcadiapublishing.com

The authors dedicate this book to their families, whose support has been invaluable, and to the people of Calhoun—past, present, and future.

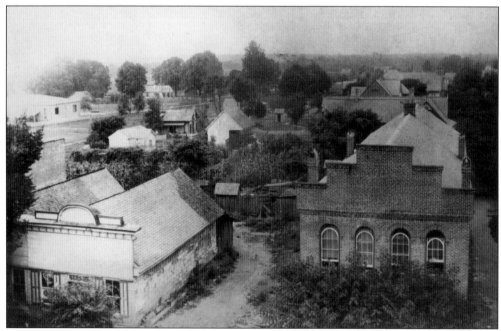

From the balcony (later removed) of the Doughty Building, on the southwest corner of Court and Wall Streets, the view in this photograph looks north over the W.A. Foster building to the right and the Hillhouse warehouse to the left. Wall Street is farther to the right at the edge of the image. Judge Thomas A. Foster had the building constructed in 1877, and his son Faw remodeled it in 1897. (Courtesy of the Gordon County Historical Society.)

CONTENTS

ACKNOWLEDGMENTS

As they worked on this project, the authors enlisted advice, sought images, and gained support from many individuals and organizations, among them the members and board of the Gordon County Historical Society, notably Mary Ann Brooks, secretary; Janie and Preston Aker; Mignon Franklin Ballard; Patricia Barrett; Maude Chattam; Celia Clemons; Rita Collins; Dr. Larry Davis; Dr. Steve Engerrand, deputy director, Georgia Archives; Georgetta Frazier, Roland Hayes Museum; Mary Ruth Garrigan; David Gomez, site manager, New Echota State Historic Site; Sharon Alexander and Sarah Husser, Gordon County Chamber of Commerce; Jeff Henderson; the family of Henry Grady Lay Jr.; Clare Lewis, GEM Theatre; Lee and Bob Linn; Lynn Lowman; Helen Jane McDonald; Toni Molleson, Harris Arts Center; Eddie Peterson, City of Calhoun; Glenese Rogers; Marilyn Roland and Caris Roland, Calhoun Elks Club; John Shivers; Paul Shoffner; Kathryn Self Sproull; Donna Thomason, Donna's Hallmark; Shirley Wade; and Dr. Edward Weldon, retired director, Georgia Archives. Julia Simpson, acquisitions editor at Arcadia Publishing, has readily answered questions and provided advice, as did Natalie Miller in the early stages and Tim Sumerel in the final editing phase.

The majority of images in this volume come from the collections of the Gordon County Historical Society. They are reproduced with the society's permission. Other images are courtesy of New Echota State Historic Site (NESHS), the Vanishing Georgia Collection of the Georgia Archives (VG), and individuals or organizations named in a courtesy line. Unless otherwise noted, a single caption for two images on a page refers to them from top to bottom.

The historical society's collections come from many sources. The late John M. Brown, a vice president of the society for many years, collected hundreds of images from individuals around the city and county. He gave much of his collection to the historical society. Other individuals either donated or lent for copy their own family photographs. Dr. Larry Davis provided images from his extensive private collection of historic material. The authors are especially grateful for the generosity of all who shared their treasures for this publication.

INTRODUCTION

Nestling 'mong mountains,
Sparkling with fountains,
Beautiful city, Calhoun! . . .
Thy beautiful river
Flows onward forever
. . . he passes no city like thee . . .

So wrote Georgia poet laureate Ernest Neal in 1920 about the city in which he taught for many years and served as a representative to the Georgia General Assembly from 1913 to 1914.

The city Professor Neal describes lies in the hills of northwest Georgia, a land inhabited by Native Americans until near the middle of the 19th century. The topography, called Ridge and Valley, is characterized by long shale, limestone, and sandstone southwest-to-northeast ridges and river valleys. Their varied geography and vegetation make the ecoregion the most diverse in Georgia.

Formed by the confluence of the Conasauga and the Coosawattee Rivers, the Oostanaula River flows by Calhoun to join the Etowah at Rome on its course to the Coosa in Alabama. The rivers were crossed by shallow fords and, successively, wooden covered bridges, iron-framed spans, and modern concrete structures. At one time, the Oostanaula was plied by steamboats as far north as Calhoun.

When the Cherokees left the area in the 1830s, forcibly removed on the infamous Trail of Tears to Oklahoma, small farmers and tradesmen claimed the land through a state lottery. As Indian trails became roads crisscrossing Gordon County, small settlements grew at intersections. Their schools, churches, and stores took on names from Antioch and Audubon to West Union. In 1911, there were 62 rural schools in the county.

An election in 1850 following a major donation of land designated Calhoun the Gordon County seat, edging out the more centrally located Big Spring. The town's population at the time numbered 150. The name of Calhoun, originally called Dawsonville or Oothcaloga Depot, honors South Carolina statesman John C. Calhoun, who was a US senator and vice president. The Georgia General Assembly incorporated the town in 1852, established its geographical limits, and designated five commissioners to lead it. The legal description did not change from town to city until 1918.

The Western & Atlantic Railroad, now CSX, ran through downtown Calhoun. According to Lulie Pitts, first historian of the town, it was also called the Battlefield Route because of its proximity and importance to the course of Sherman's March to the Sea. A block to the east of the railroad is Wall Street, named for a prominent citizen who was one of the town's first five commissioners. The street is also US Highway 41, called the Dixie Highway, a major route between the South and the Midwest. The completion in 1929 of the final section linking Atlanta and

7

Chattanooga was the occasion for a motorcade and celebrations in towns along its path. Both the railroad and the highway were critical to the area's burgeoning textile industry.

Textiles were a natural outgrowth of northwest Georgia's many small farms that grew cotton and subsistence food crops. Small cotton mills spun thread, first shipped out of state, later woven into sheeting that workers stamped and tufted (colloquially, "turfed") by hand to make chenille bedspreads. As the process became mechanized, men and women went to work in the Calhoun mills, leaving their small farms with fallow, eroding fields.

One of the early mills was called Mount Alto, for a small mountain—or large hill—on the east side of downtown Calhoun, where the owner lived and where he started the tufting business in his garage. The hill was also called Peach Orchard Hill for the crop that for a few years added to the wealth of Calhoun and Gordon County farmers. For many years, the main part of Calhoun was bounded on the east by Mount Alto, Mount Pisgah, and Boulevard Heights, an early residential retreat above the flat downtown streets. To the south, the large farm of Richard Peters prospered, producing crops and livestock under the management of his daughter Nellie Peters Black and her family in the early 20th century.

Calhoun's first paved streets were brick, laid on the business streets in 1889. Only three years later, an ordinance banned livestock, excluding that used for transportation, from streets and parks. Two parks graced downtown Calhoun in the late 19th and early 20th centuries—Gentlemen's Park and Ladies' Park. Both were favorite destinations for the county's farm families who came into town on Saturday to trade, purchase necessities, and socialize.

An early goal of the Calhoun Woman's Club, organized in 1902, was to provide a restroom in the Ladies' Park for the farm women who were inconvenienced by a long day in town. The Woman's Club then had erected in the park a small, log cabin clubhouse that became the town's first public library. Not until the 1960s did a larger, more modern building on the site of the original cabin become Calhoun's library.

Other efforts to inform and educate the town's citizens brought about the Calhoun public school system, established in 1902. Earlier educational efforts were private academies and normal schools that developed courses of study, from Latin to household tasks, that today's children would find daunting or amusing. In 1924, the owners of the Echota Cotton Mill, with aid from Gordon County, established a school for children who lived in the mill village that lay at the northern city limits now part of Calhoun proper. Echota Mill Village consisted of 150 houses for mill workers and their families. Academies and Gordon County University, in the 19th century, and Georgia Northwestern Technical College, in the late 20th and early 21st centuries, serve as examples of the importance of education to this community.

The arts enriched the lives of Calhoun's citizens from the town's early years. Children recited literary classics for graduations and Woman's Club meetings. Orchestras formed within churches to enhance religious and civic ceremonies. A world-renowned classical tenor, Roland Hayes, was born near Calhoun to former slaves in 1887 and went on to perform for royalty. He returned to Calhoun several times to sing in the high school auditorium to capacity crowds. Two modern venues for entertainment grew from old downtown structures. The Calhoun Gordon Arts Council's Harris Arts Center occupies the former Rooker Hotel, enlarged and enhanced to contain performance space, teaching studios, and art galleries. Two blocks away, the restored GEM Theatre, originally a movie theater, brings live entertainment to the city. Both fall within the city's downtown historic preservation district.

This volume of historic photographs evokes memories of Calhoun's early days, from Native Americans to children who are the hope of tomorrow, the winter of life to the spring:

Recollections are flowers
In memory's bowers,
And they bloom in December and May.

One

LAND OF THE CHEROKEE

When Hernando de Soto and his troops marched into what would become Gordon County, they encountered the Coosa chiefdom, a large Native American alliance near the Coosawattee River in Gordon and Murray Counties. De Soto's troops left the area about 1540, also leaving destruction and disease against which the natives were defenseless.

Remains of the diminished chiefdom joined to form new groups, among them Cherokees. After the American Revolution, Cherokees, strongly divided in response to the new nation, were encouraged by the federal government to emulate white ways. A centralized Cherokee society in 1827 became the Cherokee Nation, with a governing body and constitution modeled on that of the United States. The Cherokees established their national capital at the confluence of the Coosawattee and Conasauga Rivers, naming it New Echota, or New Town. They laid out a formal village, vestiges of which are seen today along with reconstructions.

Because whites were settling in northern Georgia, the state surveyed and divided Cherokee land by lottery, awarding it to the whites. Though the natives resisted, the discovery of gold in 1829 in Cherokee territory led to increased pressure on the state and federal governments to remove the Indians.

The United States Congress in 1830 passed the Indian Removal Act, which divided Cherokee leadership, with one faction advocating moving to lands in the West, the other hoping to stay in its homeland. Leaders favoring removal signed the Treaty of New Echota in 1835 and began an orderly move, but others resisted until federal troops forcibly removed them in 1838. Families were herded from their homes with few possessions, penned in stockades, and sent on land or water routes to the West. About 16,000 Cherokees began the long Trail of Tears. They left more than 4,000 of their number in graves along the way on the "trail where they cried."

The Cherokees who stayed went underground, hiding in the hills to escape detection. Many intermarried and denied their native roots. Today's part Cherokees again acknowledge their heritage, proudly working to preserve the quiet beauty of New Echota and the county they call home.

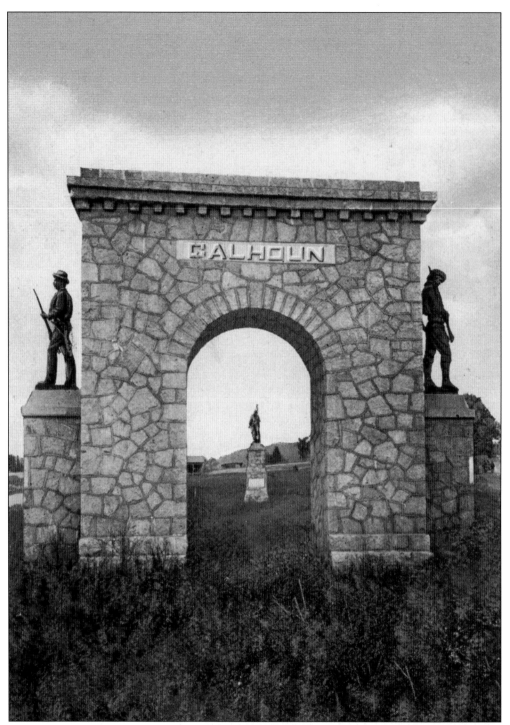

The Arch is a small park at the northern end of Calhoun at the intersection of US Highway 41 and Georgia State Route 225, which leads to New Echota State Historic Site. The area was called the Battlefield Route because Civil War troops marched near it. The statue to the right is a World War I doughboy; Sequoyah is framed by the arch, and to the left is a Confederate soldier.

Elias Boudinot, originally Galagina, or Buck Oowatie, studied at Spring Place mission northeast of New Echota, at a mission school in Cornwall, Connecticut, and at Andover Theological Seminary. He was the first editor of the *Cherokee Phoenix*. Due to Boudinot's attempts to describe both sides of the Cherokee schism in 1832, principal chief John Ross forced him to resign. As a signatory of the Treaty of New Echota, Boudinot agreed to the Cherokee removal. In 1839, he and two other leaders were assassinated because of their perceived betrayal. Boudinot and another Cherokee student, John Ridge, fell in love with and married white women whom they met at the Cornwall School. The two interracial marriages caused such strife in the town that the school was forced to close in 1827. Boudinot and his wife, Harriet Gold, pictured here, were burned in effigy during the protests.

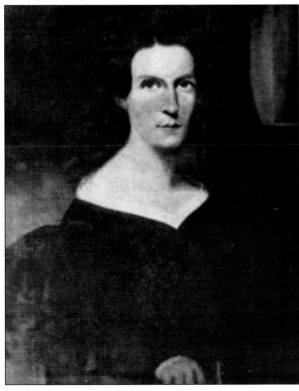

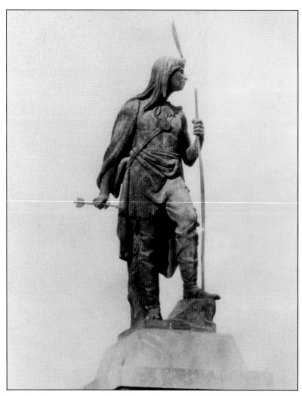

Two statues commemorating Sequoyah, creator of the Cherokee syllabary, stand in Calhoun—one at the Arch at the northern edge of the city and one in Bicentennial Park. The statues are idealized depictions of Native Americans and have little in common with Cherokees, who generally dressed as whites did. The statue in Bicentennial Park, to the south of the Calhoun Gordon County Library, was first placed at the old Calhoun School in 1913. It was moved when the school was demolished in 1974. The park had originally been the Ladies' Park, site of Calhoun's first library.

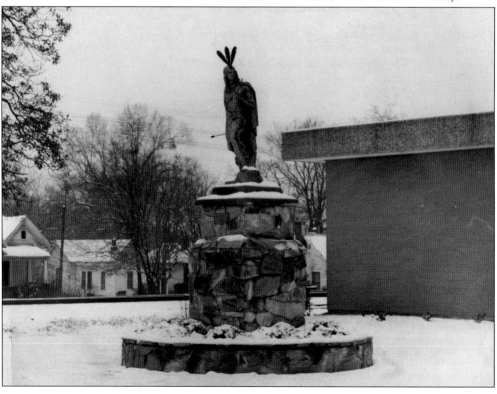

Georgia poet laureate Ernest Neal recited his poem "The Indian's Heart" when the federal government erected a monument in 1931 at the site of New Echota. Here, he reads to his grandchildren after he was named poet laureate in 1927. Professor Neal had taught at Calhoun and several Gordon County schools. When he was reduced to near penury, Gov. Eugene Talmadge made him curator of the Georgia Capitol Museum.

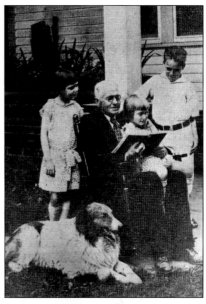

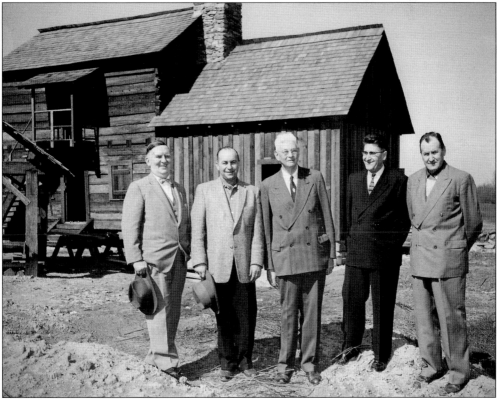

Several men who had played a part in the restoration and reconstruction of New Echota gathered to check progress on Vann's Tavern in late 1957. Construction on the tavern and the Worcester House went on from 1955 to 1959, and the tavern officially opened in 1962. Pictured here are, from left to right, C.F. Gregory, John Slagle, J. Roy McGinty, R.D. Self, and Henry Mauldin. (Courtesy of Kathryn Self Sproull.)

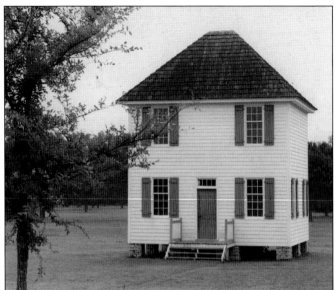

Reconstruction of the Supreme Court building of the Cherokee Nation was completed by the opening of New Echota as a public park in 1962. For a few years in the late 1820s, the Cherokees lived under a remarkable form of constitutional government. Their court met in the fall and could hear both civil and criminal appeals. The Supreme Court of the State of Georgia held a session at this building in 1993.

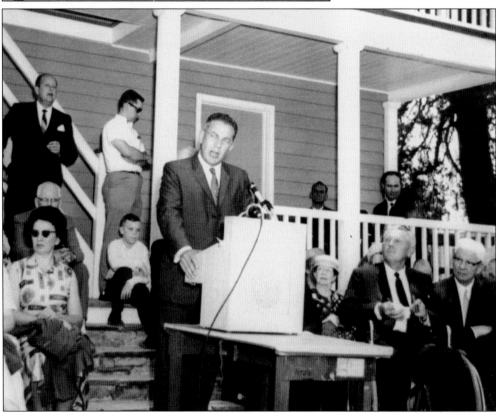

The Worcester House is the only structure at New Echota that stands on the original site. Samuel A. Worcester, an American Board missionary, was postmaster at New Echota until he was evicted and his house commandeered by the State of Georgia in 1834. Gov. Ernest Vandiver (at podium) speaks when the restoration was completed. Listening are Georgia Secretary of State Ben Fortson (in wheelchair) and *Calhoun Times* editor emeritus J. Roy McGinty (far right). (NESHS.)

Actors in the documentary *Give Me Liberty*, filmed for the US bicentennial, pose at Vann's Tavern. Cherokee James Vann built the tavern about 1805 at a ferry in Hall County, Georgia, where the Old Federal Road crossed the Chattahoochee River. When rising water from Lake Lanier threatened the building in 1956, it was moved to New Echota. (Courtesy of VG gor518.)

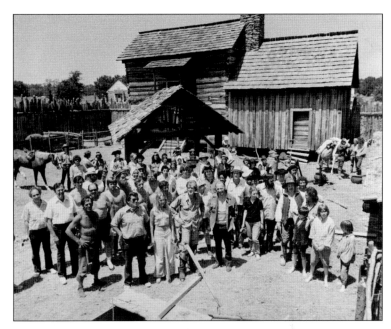

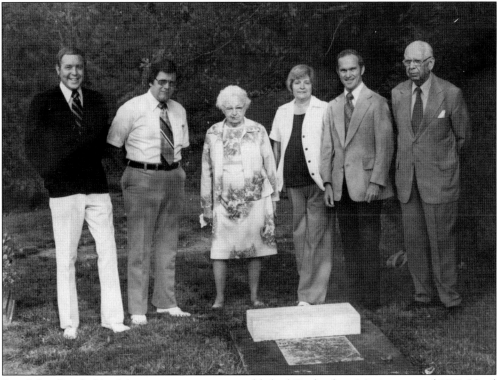

Rev. John Gambold, a Moravian missionary, established Oothcaloga Mission around 1822. Until his death in 1828, he continued to lead the slow efforts to convert the Cherokees. About that time, the mission had over 50 students, converts, and children. Whites lived in the house after the land lottery of 1832. Several members of the Gordon County Historical Society gather on May 17, 1977, at Reverend Gambold's grave on Belwood Road to commemorate a new marker.

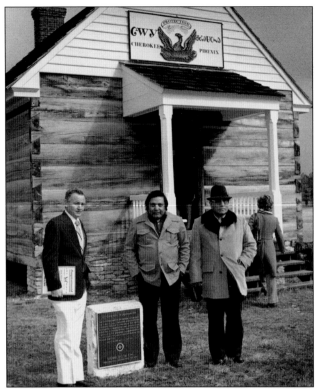

Sigma Delta Chi Professional Journalism Society honored New Echota Print Shop in 1971 as a Historic Site in Journalism. The marker reads, "The Cherokee Nation of Indians established the first Indian language newspaper, the *Cherokee Phoenix*, on this site in 1828. Edited by Cherokee Elias Boudinot and later by Elijah Hicks, the *Cherokee Phoenix* was printed bilingually in the Sequoyah syllabary, and in English, during the period 1828–1834." (Courtesy of NESHS.)

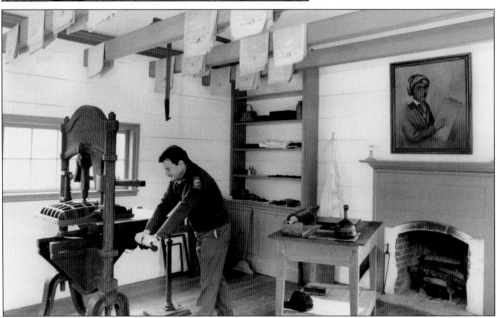

Frankie Newborn, superintendent of the historic site, 1987–1997, operates the press inside the print shop. Newly inked pages are drying on rafters above his head. The portrait over the fireplace represents George Guess, or Sequoyah, a Cherokee who over a period of 12 years devised 86 marks to represent syllables of the Cherokee language. The popular syllabary led to improved communication among the Cherokees. (Courtesy of NESHS.)

Judd Nelson, well-known Gordon County blacksmith, stabilizes Sequoyah during his move from the school to the park. Nelson has been featured in the Smithsonian Folklife Festival on the National Mall. J.L. Mott Iron Works of New York was one of several foundries that cast similar statues for many sites in the United States. Made of zinc alloy, the statues were durable and weighed much less than cast iron.

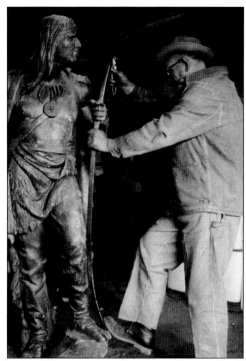

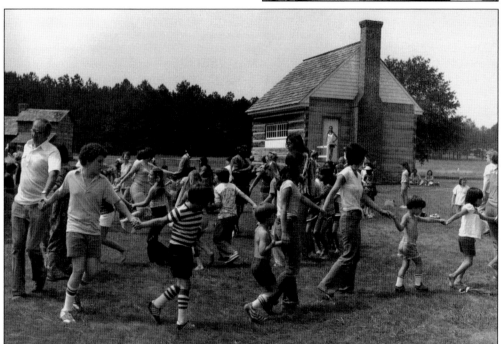

Visitors participate in a traditional game, or social dance, at the Cherokee Festival at New Echota State Historic Site in 1989. They dance in front of the print shop, reconstructed in 1960. The site sponsors or hosts many events throughout the year, including a Cherokee Youth Leadership Remember the Removal Ride overnight stop at the beginning of an annual bicycle ride to commemorate the Trail of Tears. (Courtesy of NESHS.)

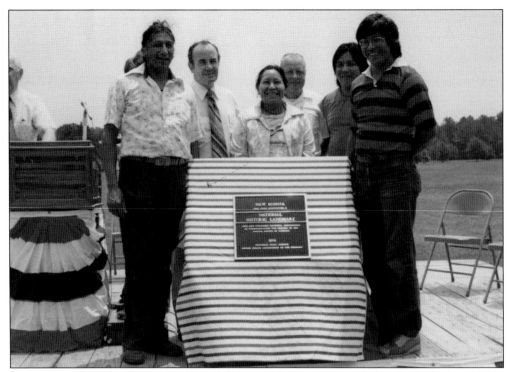

Cherokee leaders who traveled to New Echota in 1976 stand around the plaque declaring New Echota State Historic Site a National Historic Landmark. The monument commemorating New Echota originally stood in 1934 atop a small hill now occupied by the 14th hole of the Elks Club Golf Course, known to players as the monument hole. In 1988, as part of the 150th memorial of the 1838 Trail of Tears, the monument was moved across Georgia Highway 225 to the grounds of the New Echota State Historic Site. (Below, courtesy of the City of Calhoun.)

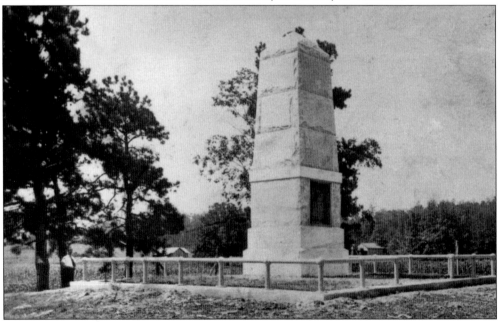

Two

CALHOUN GOES TO WAR

Until the Civil War, northwest Georgia was relatively unaffected by warfare on the American continent. Log palisades excavated at Etowah, a few miles south of Calhoun, are evidence of Native American conflicts during the Mississippian period, but skirmishes only occasionally characterized the normally peaceful Cherokees' reluctance to move west during the early 19th century.

Though Georgia was one of the original 13 colonies, the northwest part of the state was too isolated and sparsely populated to be involved in the American Revolution.

War came to Calhoun and Gordon County, however, in May of 1864, when Confederate troops attempted to halt the momentum of Union soldiers' march toward Atlanta. With the help of Federal forces moving through Snake Creek Gap, Gen. William T. Sherman's 110,000 men outflanked and initially outnumbered Gen. Joseph E. Johnston's Confederates about two to one and eventually overwhelmed them at the Battle of Resaca. Following the battle, Union troops almost destroyed Calhoun on their way south, leaving only a few houses, including Oakleigh, home of the Gordon County Historical Society since 1974.

Since the Mexican-American War, Calhoun citizens have done their part in the nation's armed conflicts by serving in the military, in the home guard, at the Bell Bomber plant in Marietta, or in auxiliary groups who sewed and wound bandages for the Red Cross. Calhoun natives of a certain age still remember saving balls of tinfoil and string and watching their parents collect coupons for the purchase of scarce commodities during World War II. Some people worked as far away as Marietta to join the war effort at the bomber plant.

The Gordon County Historical Society's small museum has memorabilia from war veterans whose families have chosen to share their distinguished past. Members of the American Legion and Veterans of Foreign Wars periodically commemorate combatants. A National Guard Armory near the structures displays a tank to remind citizens that "weekend warriors" always stand ready to defend them.

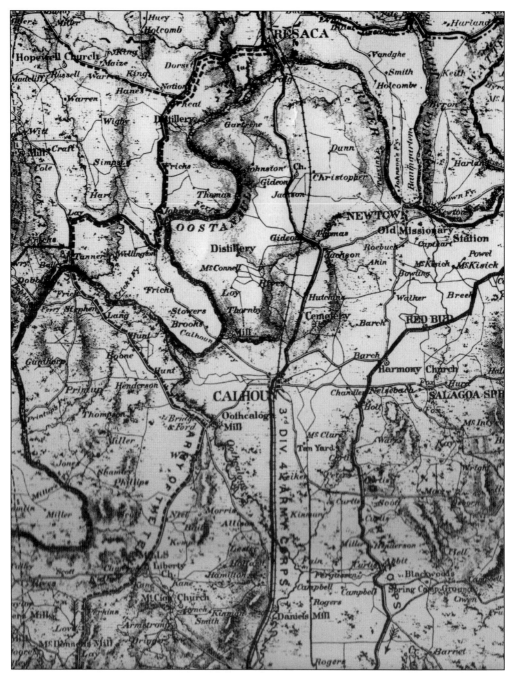

Civil War Map II of the Military Operations of the Atlanta Campaign, 1864 (published 1877), shows the position of the 3rd Division 4th Army Corps along the railroad due south of Calhoun. The Army of the Tennessee line runs southwest from Oothcaloga Mill. The Oostanaula River meanders from Resaca (top of the map), site of a pivotal battle, to the west of Calhoun.

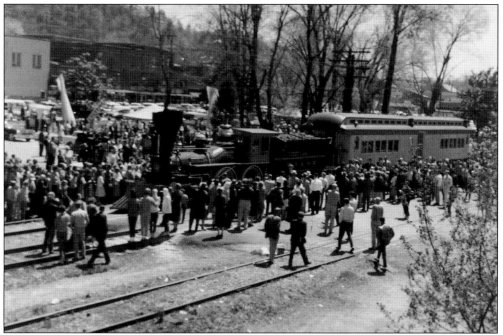

Union spy James J. Andrews and several volunteers from the Ohio infantry in April 1862 commandeered the *General*, an engine of the Western & Atlantic Railroad, at Big Shanty, now Kennesaw, Georgia. Their course led them north through Calhoun before Confederates captured them at Ringgold and executed eight of them. The rest escaped. In 1962, the *General* visited Calhoun as part of the centennial of the Andrews Raid.

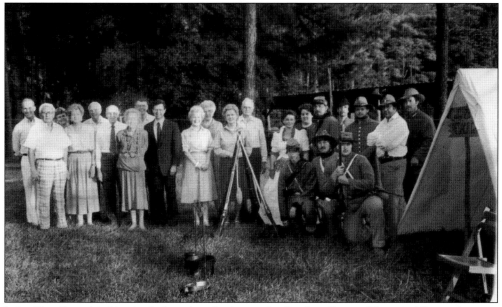

Judge Tom Pope (civilian in dark suit) spoke during the Gordon County Historical Society's spring meeting at Cedar Hill Lake in 1987. Judge Pope reprised his speech on the logistics of the Battle of Resaca, which he had given the year before at the memorial service at the Resaca Confederate Cemetery. Reenactors in period dress added verisimilitude to the gathering.

The American Red Cross has been a vital part of war efforts in Calhoun. Organized on July 4, 1917, by the Calhoun Woman's Club, the local Red Cross chapter had leaders from across the community. They included club women, physicians, Girl Scouts, and a junior Red Cross chapter. A first aid class benefitted from instruction by a local physician and advice from an official in Washington, DC. The Red Cross flag was prominent in the background when members of the Gordon County unit stood on the steps of the Woman's Club cabin in 1939. They are, from left to right, (first row) unidentified Red Cross representative, R.L. Blackwell, and A.B. David; (second row) R.L. Crutchfield, Dr. Roy Richards, Dr. J.H. Boston, and J.C. Fox.

Some 1,917 Gordon County men were eligible for service when the United States entered the war in 1917. In the photograph at right, Eugene Moss (left) and Daniel Tobias Strain, both from Gordon County, signed on to serve after the United States entered World War I. Other recruits gathered at the Calhoun depot in 1918 before departing by rail for training camp. The Paul Gwin Post of the American Legion, chartered in 1919, was named for the first Gordon County man to lose his life in World War I. Gwin enlisted immediately after the United States declared war, and his two brothers were seriously wounded in action as well. (Right, courtesy of VG gor017.)

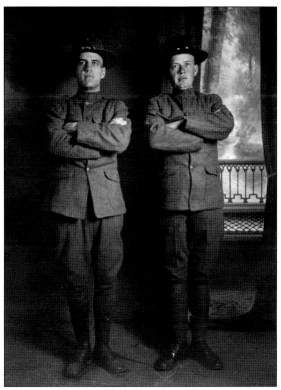

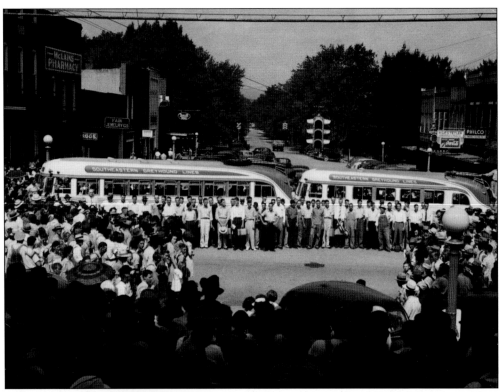

During World War II, a group of 57 men bound for the United States Army boarded Greyhound buses in front of the Gordon County courthouse. A large crowd of well-wishers saw them off on July 17, 1942. Men and women from the area have served in every major conflict since the Mexican-American War of 1846–1848.

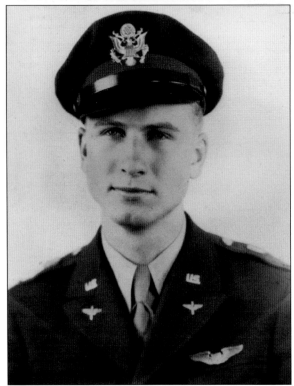

Lt. Gen. Ray B. Sitton (1924–2013) had a distinguished Air Force career that included service in World War II as a pilot in the southwest Pacific and in Korea. He also served at the National War College, at the Strategic Air Command, and, last, as director of operations (J-3), Joint Chiefs of Staff in Washington. Born and educated in Gordon County, he is a second lieutenant in this 1944 photograph.

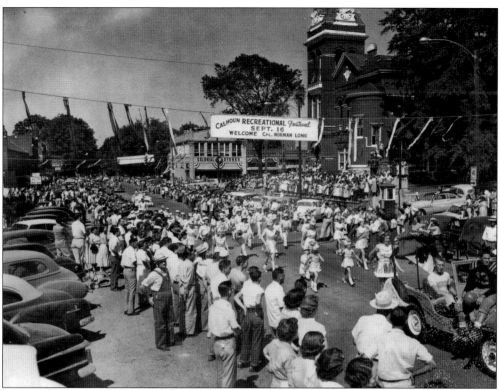

A parade in 1953 honors Cpl. Norman Long, who, during the Korean War, was captured by the North Koreans and turned over to the Chinese Communists. He marched for 31 days to Camp Pyoktong. Held prisoner for 27 months, he was repatriated in what was known as the Little Switch. Estimates are that 40 percent of US Army prisoners of war did not survive the Communist camps.

A cenotaph dedicated to Gen. Charles Haney Nelson and placed on the courthouse grounds was relocated to make room for a new courthouse in 1975. Workers who moved the 20-foot-high monument settle it in a traffic island at Oothcaloga Street and Park Avenue. It has since returned to the new courthouse grounds. General Nelson participated in the Cherokee removal, fought in the Mexican-American War, and settled at Big Spring in Gordon County.

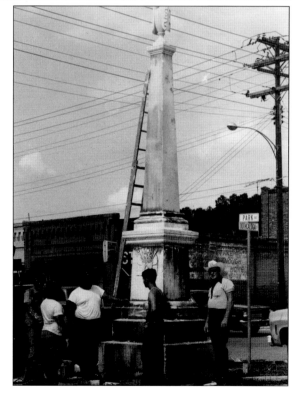

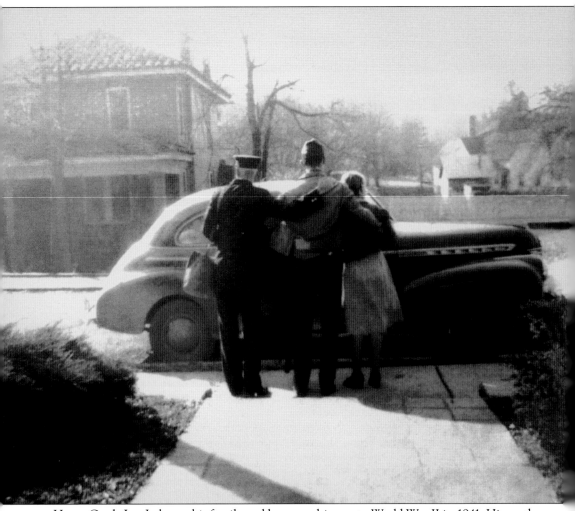

Henry Grady Lay Jr. leaves his family and home on his way to World War II in 1941. His mother, Anabel Ruddell Lay, and his father, Henry Lay Sr., both pictured here, had six children. Henry Sr., who started Meadowbrook Dairy, became Calhoun's fire chief, a painting contractor, and a postal employee.

Three

HOT TIMES IN
THE OLD TOWN

Early images of Calhoun show people at work and play, enjoying their natural and built surroundings. Ample opportunities for recreation included city parks, parades through downtown streets, rivers, and Amakanata and Dew's Pond in the country.

The Chattahoochee National Forest, on the western side of the county, remains a destination for hunters, hikers, and anglers. The Pocket Recreation Area and Keown Falls have hiking facilities, some camping, and picnicking. Near the forest, Camp Sidney Dew and Camp Gazelle Dew for years drew Calhoun's Boy and Girl Scouts for their summer programs.

Several golf courses have come and gone through time. The Elks Golf Club, on property leased from the state on land that was once part of the Cherokee capital New Echota, was first a country club. A newer course is Fields Ferry, owned and operated by the City of Calhoun, which rolls across picturesque fields once farmed by the Owens family.

Friday nights in the fall find much of Calhoun cheering at a football game or sitting by the radio, tuning in. The high school has excellent sports teams as well as musical and literary talent.

Parades through downtown Calhoun have traditionally passed the courthouse and gone near Gentlemen's and Ladies' Parks. The library, which originated as a log cabin in Ladies' Park, was known until the 1960s merely as "the Cabin." Special occasions brought spectators to the park for band concerts and picnics.

Casual rides on horseback, horse shows, and rodeos have long been entertainment for this town with rural origins. Horses and buggies led to vehicles with engines, ever-popular recreational as well as working vehicles around town. Some folks belong to a convertible or motorcycle club, while others use antique tractors as jitneys for citywide festivals. Train wheels took them on excursions and high school senior trips back when passenger trains stopped at the depot.

Calhoun's residents knew when to have fun and when to be serious. Photographs document both pursuits.

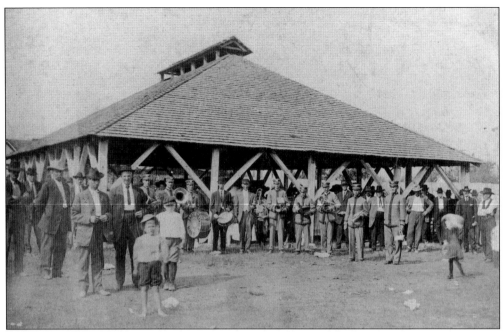

A concert and picnic at the Pavilion Fair Grounds drew an audience when the Belmont Band performed in 1897. A racetrack and the Pine Thicket were south of the site. Well into the 20th century, when the fair was in town, traveling carnies camped there in the dense trees. The Calhoun Yellow Jacket football team plays in 2014 in Phil Reeve Stadium on the site of the pavilion.

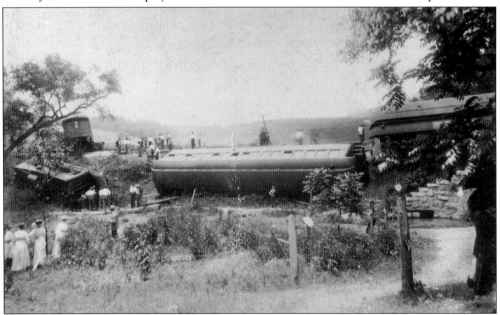

Residents of Calhoun and Gordon County were in a festive mood on June 12, 1912, as they packed picnics and boarded the Western & Atlantic Railroad for an excursion to Chickamauga Battlefield Park. The outing ended in tragedy near Willowdale, in Whitfield County, when the passenger cars derailed. The people of Willowdale turned out to bring blankets and administer first aid to victims, but two people died in the wreck

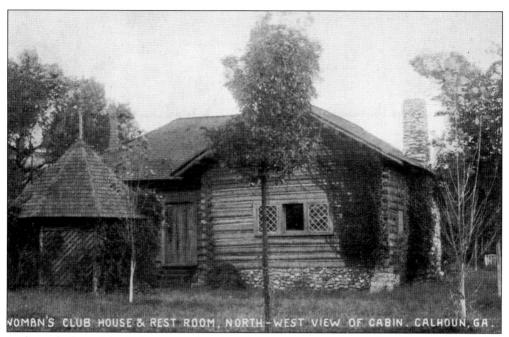

WOMAN'S CLUB HOUSE & REST ROOM, NORTH-WEST VIEW OF CABIN. CALHOUN, GA.

In the early days of the 20th century, farm families who went to town on Saturdays congregated in the Gentlemen's Park and the Ladies' Park, at the intersection of Court Street and Park Avenue. The Calhoun Woman's Club in 1902 built a log cabin clubhouse in the Ladies' Park with restroom accommodations for women spending the day in town. When a water main was laid under Park Avenue in 1917, the ladies' public restroom was still operating, The legend on this postcard, mailed in 1916, reads "Woman's Club House & Rest Room, North-west View of Cabin, Calhoun, Ga." The sign to the left in the construction photograph points out "Ladies' Rest Room." Fittingly, the motto of the woman's club was *non sibi, sed pro aliis,* "not for self, but for others."

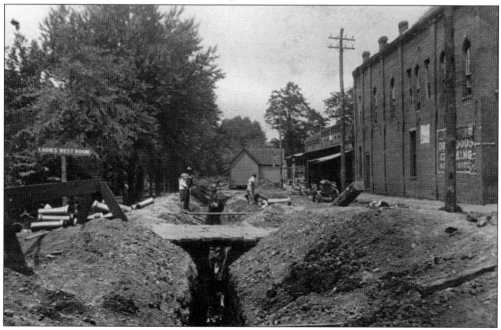

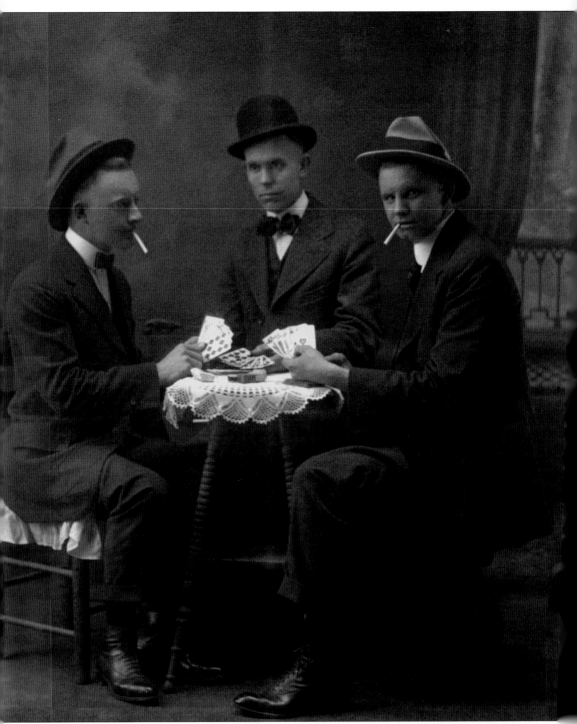

Card parties have long been a favorite pastime in the community. Private individuals as well as organizations have played for pleasure and occasionally to raise funds. These young men most likely are not playing at a ladies' luncheon as they pose in 1918. They are, left to right, Charlie Miller, Jay Bird Gordon, and Billy Owen.

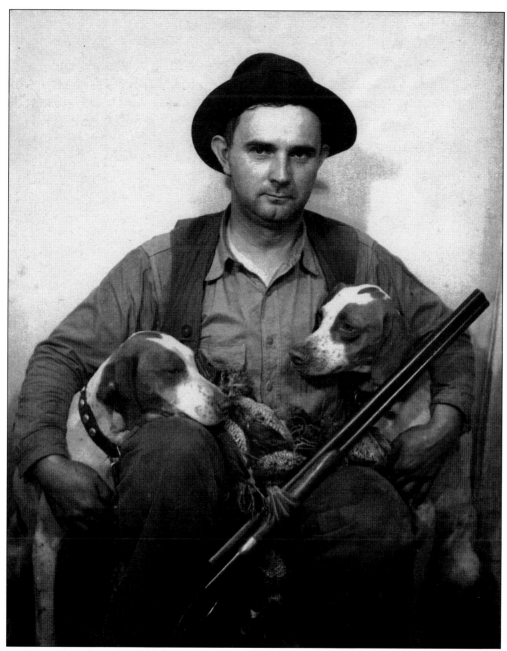

Phil Reeve, Calhoun businessman, member of the Georgia Yellow Hammers string band, and manager of the band, was an avid sportsman. After attending Georgia Tech and playing the trumpet in its band, he named Calhoun's team the Yellow Jackets for the Tech mascot. Here, Reeve and his hunting dogs, Pat and Bud, relax after hunting quail in the 1930s. (Courtesy of Jane Powers Weldon.)

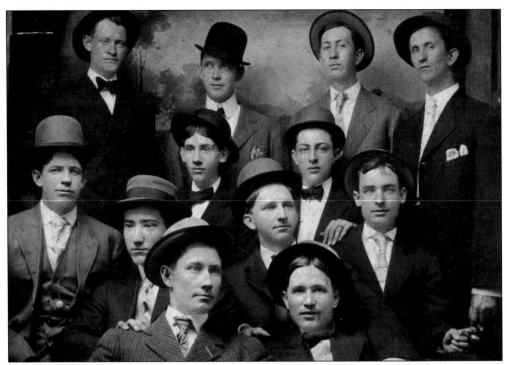

Several young men pose in their bowler hats, possibly purchased from A.R. McDaniel, in 1915. In the center of the second row, looking slightly to the viewers' right, is Claude David, an early banker who was an officer of the Calhoun National Bank.

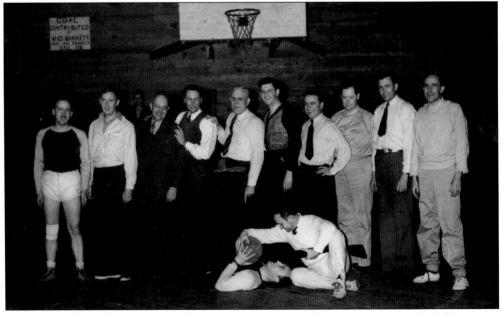

Members of the Calhoun Rotary Club clown around to publicize a charity basketball game in 1939. Rotary has long been an active service organization, sponsoring international exchange students, dinners and barbecues, and other activities. The old tin-sided wooden gymnasium burned in 1950 and was replaced by a brick structure.

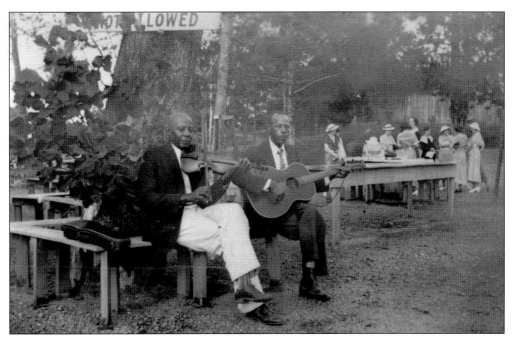

Afro Cherokee fiddler Andrew Baxter (left) and his son Jim were popular entertainers in Calhoun in the 1920s through the 1940s. At a recording session in Charlotte, North Carolina, for R.C.A. Red Seal, Andrew Baxter joined the Georgia Yellow Hammers for "G Rag." That performance was among the earliest integrated recordings. Andrew Baxter was born in 1869 in Coosawattee, Gordon County, began fiddling at age nine, and died in 1955.

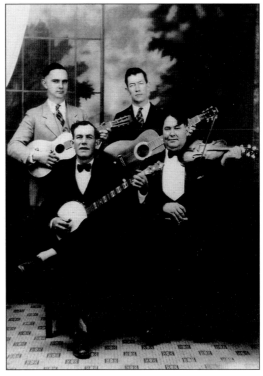

The Georgia Yellow Hammers were a Calhoun-based string band that performed across the Southeast and recorded for national labels in the late 1920s. Their work and that of the Baxters is honored in the annual Georgia String Band Festival at the Harris Arts Center in Calhoun. Band members are, from left to right, (first row) Bud Landress and Bill Chitwood; (second row) Phil Reeve and Ernest Moody. (Courtesy of Dixie Landress and Paul Shoffner.)

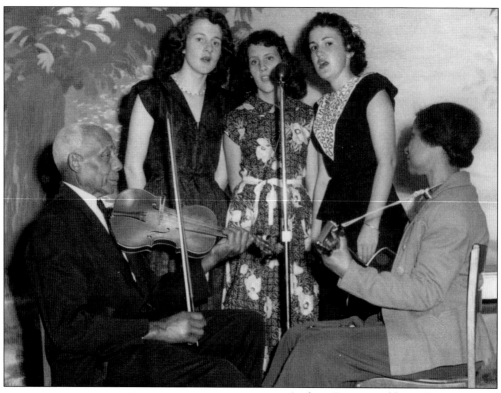

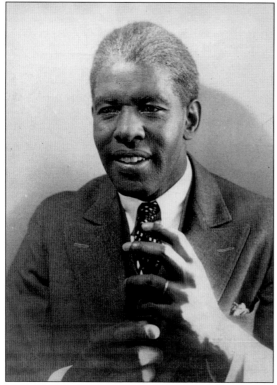

Andrew Baxter and his wife, Leola, pretend to accompany the Red Bud Trio in the spring of 1951. The singers are, from left to right, Katherine Swanson Quinn, Sue Stanfield Hensley, and Bonnie Whitfield Ross. According to Hensley, Leola Baxter set up the session to trick her husband into dressing up in a suit and tie for a photograph. (Courtesy of Sue Hensley and Marshall Wyatt, Old Hat Records.)

Roland Hayes (1887–1977), a son of former slaves, was born in western Gordon County. He went on to become an internationally acclaimed concert tenor. This photograph, according to a notation on the back, was "snapped in Mexico City, D.F." Hayes is "demonstrating, with his hands, the manipulation of an African bamboo trumpet for interested Native Mexican musicians." The Roland Hayes Museum is a part of the Harris Arts Center. (Courtesy of the Roland Hayes Museum.)

Dew's Pond, pictured here in the 1930s, was a popular recreation area for Calhoun's young people, who packed picnics and spent the day. The lake is fed by a spring that Native Americans called Big Spring. Now owned by the City of Calhoun, it has an output of 8 to 10 million gallons a day, large enough for the city to use and sell to nearby towns.

Logan's Mill was situated on Oothcaloga Creek on the western border of the town before the Civil War, when it was called Oothcaloga Mill. After John William Logan came to Calhoun in 1885, he acquired the gristmill; he also operated a livery stable and the Haynes House hotel. The mill was torn down in 1955.

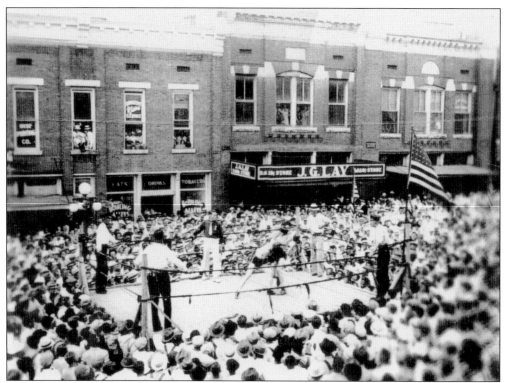

A crowd gathers in the center of Court Street in the 1920s to watch colorful Calhoun native Pat Logan participate in a prizefight. Logan's father, John, was an early entrepreneur who traded in real estate and mules, ran the Calhoun Hotel, and operated Logan's Mill, situated on Oothcaloga Creek. (Courtesy of Dr. Larry Davis.)

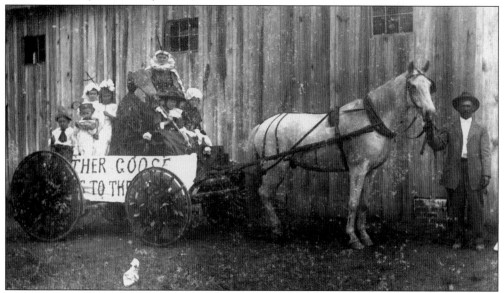

Parades have long been a favorite diversion for Calhoun's citizens, as this Mother Goose parade in 1900 demonstrates. Nothing else is known about the occasion or participants in this charming image.

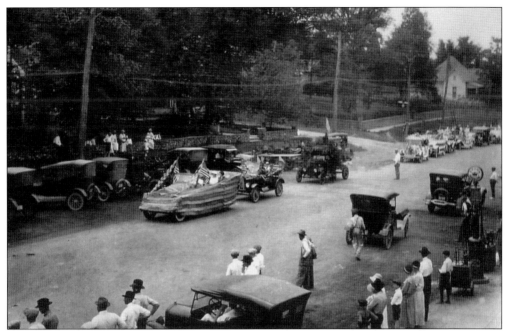

The clothing and automobiles in this photograph indicate that the parade took place in the 1910s. Boys sported knickers, and the women wore long skirts and hats. The gas pump on the curb belonged to a service station on South Wall Street. The street was named not for the rock walls that lined it but for one of the town's first commissioners, Dr. W.W. Wall.

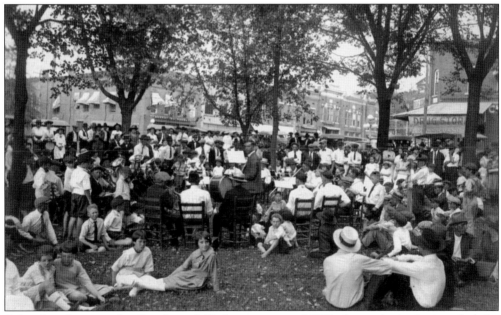

A band performs in the Gentlemen's Park in summer of 1923. A popular gathering place for spectators to watch passengers alight from trains at the depot just across the tracks, the park and the Ladies' Park were beautified by the Calhoun Woman's Club. The street between the two was known as the Cotton Block, where factors bid for bales of cotton. (Courtesy of the City of Calhoun.)

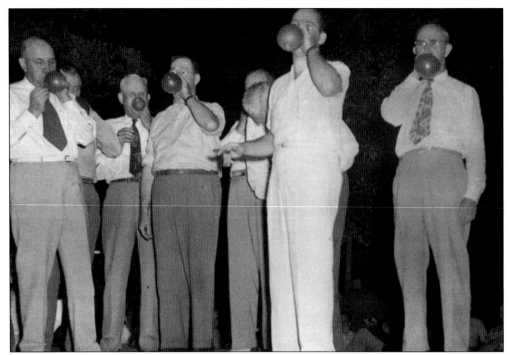

The Rotary Club held annual fish fries and chicken barbecues at Amakanata Fish Hatchery between the 1930s and the 1950s. The evenings were characterized by songs, silly games, lots of conversation, and the sergeant-at-arms's humorous introduction of spouses and other guests. In the early 1940s, blowing up balloons was evidently one of the silly games.

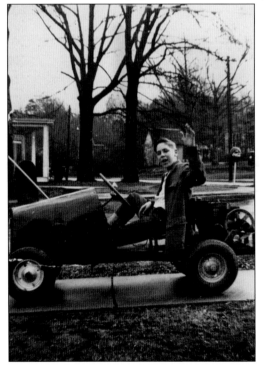

A young John M. Brown, later compiler of the volume *Yesteryears* and longtime vice president of the Gordon County Historical Society, waves from a go-cart. Brown was an avid collector of historic images from Calhoun and Gordon County. After publishing a book of his photographs, he donated much of the material to the historical society.

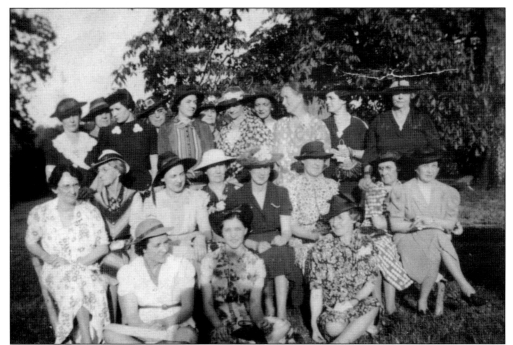

The Hillhouse Garden Club gathers at the country home of Elizabeth Lang in 1939. Named for Calhoun builder and mayor W. Laurens Hillhouse (1861–1951), the oldest garden club in Calhoun serves a social and a civic function in the community. The ladies' attire is typical for a meeting of the period.

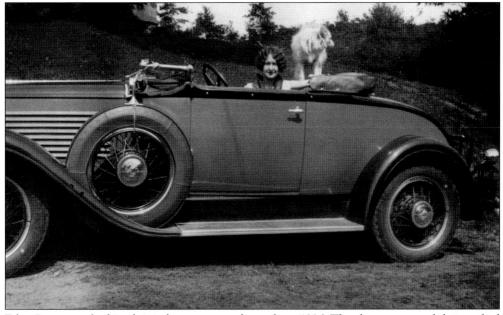

Edna Boston and a friend sit in her sporty roadster, about 1926. The elegant automobile is parked in front of the Boston home, Mount Alto, overlooking downtown Calhoun. Her father, Dr. J.H. Boston Sr., was a pioneer in the textile industry who founded Mount Alto Bedspread Company in the early 1920s.

Dr. J.H. Boston Sr. stands in front of his home on Mount Alto. His company supplied cotton sheeting to individual workers around the county who then stamped the cloth with patterns and tufted it into chenille products. As the textile business grew in the South, Mount Alto expanded into a one of the county's first mechanized producers.

An enduring recreational site for Calhoun was the country club, now the Elks Golf Club. First called the Sequoyah Golf Course, it was built in 1949 on part of the lands of the New Echota Cherokee settlement. When the course is not flooded, golfers enjoy the beautiful, rolling course at the confluence of the Conasauga and Coosawattee Rivers. This group played in the 1960s. (Courtesy of Calhoun Elks Lodge.)

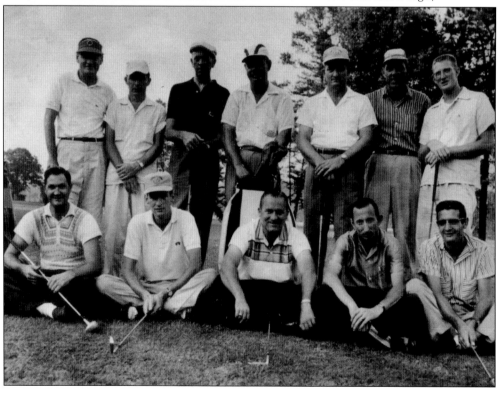

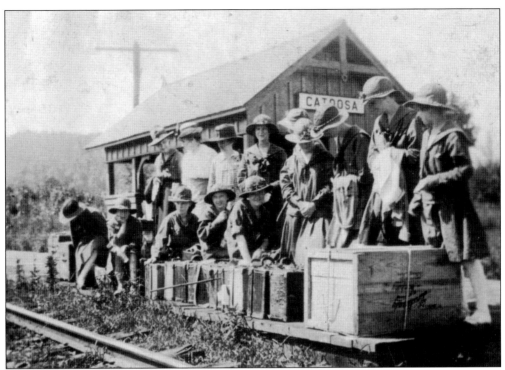

A photographer found a group of Girl Scouts on their way home from a camping trip to Catoosa Springs around 1920. The group seems to be divided between those reluctant to leave camp and those excited about returning home.

Girl Scouts became active in Calhoun a few years after a Boy Scout troop began meeting in a log cabin behind the Woman's Club cabin. The first band of Girl Scouts was organized by Mattie Harlan in 1912. Miss Doris Crutchfield, remembered by many as the cashier at the old Gem Theatre, was a Girl Scout captain then and a leader well into the 1920s.

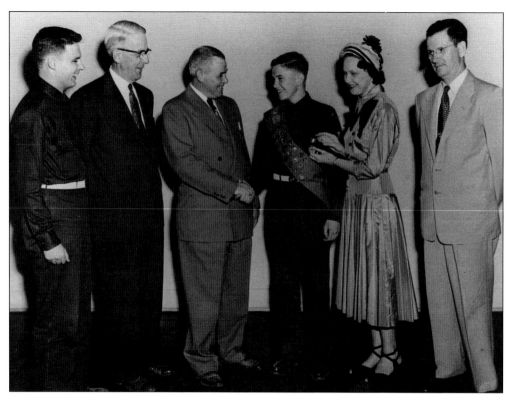

Boy Scouts have a long tradition of service in Calhoun that includes a dramatic artificial respiration rescue during a swimming party at Amakanata in the mid-1930s. Here, new Eagle Scout Tommy Brown, in the early 1950s, is congratulated by his father as his mother, pastor, and Scout officials watch. A year or two before, Tommy had traveled to Europe to the International Boy Scout Jamboree.

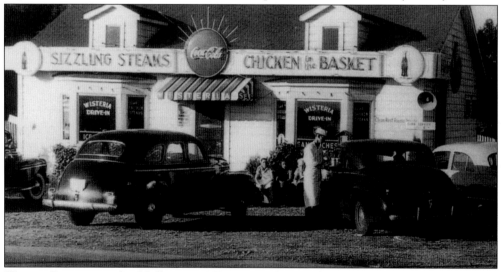

Wisteria Drive-in, south of Calhoun on US 41, was a favorite destination for high school students in the 1950s. After ball games, dances, and other school events, young people flocked to Wisteria for a burger, fries, and a soft drink. Because the establishment featured curb service, many customers never saw the inside of the building.

Four

SCHOOL DAYS, SCHOOL DAYS

Miss Lulie Pitts, first historian of Calhoun, says in her 1934 county history, "Calhoun citizens have placed a proper valuation on the importance of education since the town was created, and the maintenance of good schools has been a major object through the years." Like the bell atop the first school buildings, Miss Lulie's words continued to ring true as Calhoun grew.

Though the Calhoun Academy was established by the Georgia General Assembly in 1852, not until 1884 did the first class graduate from Gordon County University, on College Street. The old academy building and the property on which it stood were transferred to the city in 1901 for a public school, which officially opened in September 1902.

Over the years, the city added three brick buildings, each a model of efficiency at the time, and demolished the old wooden academy building. The campus was dedicated to elementary education when the high school moved to the west side of town in 1937. Other nearby modern buildings housed primary and junior high schools. The First Baptist Church purchased the original campus in 1974, demolished the old buildings, and erected a new sanctuary and educational buildings.

In the early 20th century, the Julius Rosenwald Fund established a building fund to benefit schools for African American students, primarily in the South. With the help of the endowment, Stephens School, on the northwest side of Calhoun, educated African American children from both the city and county. The highly regarded school closed when integration of white and black schools began in 1966–1967.

The state-of-the-art Calhoun High School and Middle School completed in 2014 features a handsome bell tower modeled after that of the 1902–1903 building. When the 1937 high school was demolished, the last school fondly remembered by many Calhoun schoolchildren was no more.

the business of the said firm is demanded by the Executors of Col. Dunham.

<div align="center">C. J. ELFORD,
J. B. SHERMAN,
Executors of B. DUNHAM.
ARTHUR BLEAKLEY.</div>

☞ The Wholesale and Retail business will be carried on as usual by the undersigned, ARTHUR BLEAKLEY.

Augusta, Ga., July 3rd, 1855.　n25 4t

CALHOUN
MALE & FEMALE SCHOOL.

THE First Session of this Institution will commence, under the supervision of the undersigned, assisted by Mrs. WESTER, on Monday, the 16th of July next.

In the Male Department, boys will be prepared for the Freshman Class in College. The course of instruction will be thorough: requiring the pupil to give the *why* and *wherefore*, as well as to recite accurately.

Discipline will be firm, but mild, parental and impartial.

It is the design of the Principal to build up a Preparatory School, of the first grade, in the flourishing town of Calhoun; and, if sufficient encouragement is offered, a higher Seminary will be established.

Terms per Session of Five Months:

Primary English Branches ---------- $ 7 00
Higher　　"　　　"　　 ----$8 to $10 00
Latin, Greek and Mathematics ----- $12 00

Tuition at the end of the Session. A discount of ten per cent to those who pay in advance. No deduction for absence, except in cases of protracted sickness.

It is desirable that pupils should commence as soon as possible.

<div align="right">WM. V. WESTER.</div>

Calhoun, Ga., June 23d, 1855.
　　no22　　　　　　　6t

An article from the *Southern Statesman*, October 11, 1885, announces that the Calhoun Male and Female School will open "the 16th of July next." William V. Webster stated that the principal would begin with the first grade and add a higher Seminary if "sufficient encouragement is offered." To the "flourishing town of Calhoun" he promised that "discipline will be firm, mild, parental and impartial."

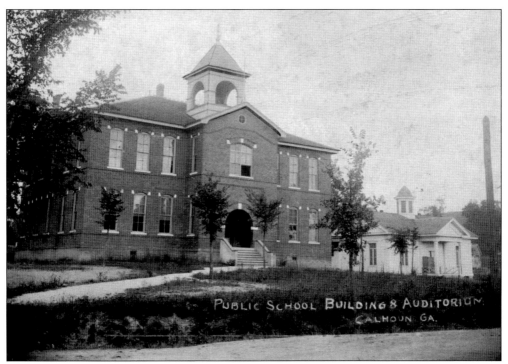

PUBLIC SCHOOL BUILDING & AUDITORIUM. CALHOUN GA.

The Calhoun school system formally began its illustrious career in 1901–1902 on College Street, in the small white building to the right. It had been the home of several other schools, including Gordon County University, from which the first class graduated in 1884. The public school began in 1902. This 1904 photograph shows both the first brick building and the old wooden academy.

A rider observes two sisters standing across unpaved College Street from the school in the early 20th century, before the academy was demolished. The small brick building at center is an outhouse. After this photograph was made, the Calhoun Woman's Club paid $160 in 1910 to have a wall built around the school grounds for erosion control. The academy had been moved south to be used as an auditorium.

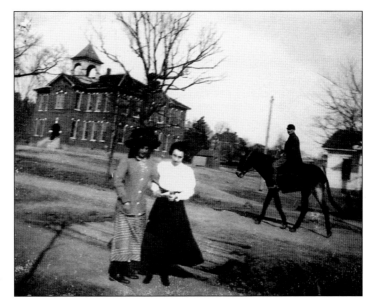

COMMENCEMENT EXERCISES.
—OF THE—
GORDON COUNTY UNIVERSITY.

➤✢✢✢✢✢◄

WEDNESDAY, JULY 2, 1884, 7:30, P. M.

"Doctrina sed vim promovet insitam,
Rectique cultus pectora roborant."--Hor.

PROGRAMME:

Cantata--The Quarrel Among the Flowers.

SPARTACUS TO THE GLADIATORS.....Declamation by Master Frank L. Malone.

ANTAGONISM................Declamation by Master Leon R. Crawford.

SOUTH CAROLINA...............Declamation by Master John A. Douglass.

MUSIC—BRANIGAN'S BAND—DUETT.

THE BUILDING OF THE SHIP.........Recitation by Miss Minnie C. Kindred.

A MOTHER'S FIDELITY.................Recitation by Miss Jennie A. Ellis.

GOOD-BYE.....................Composition by Miss Mattie I. Tinsley.

MUSIC—ROSY MORNING—VOCAL SOLO.

MUSIC—CHICAGO FIRE BELLS......................Instrumental Duett.

THE MODERN ANOMALY............Declamation by Master W. R. Rankin.

THE DYING SOLDIER.............Declamation by Master John R. Cantrell.

THE RICH AND THE POOR...........Declamation by Master W. B. Haynes.

MUSIC—TITANIA—VOCAL SOLO.

FASHION.....................Composition by Miss Carrie N. Reeve.

THE FAITHFUL LOVERS...............Recitation by Miss Florie C. Foster.

SPRING HOUSE-CLEANING................Recitation by Miss Bessie C. Fain

MUSIC AND A SISTER'S SONG—DUETT.

THE MURDERER'S SECRET........Declamation by Master Mark A. Matthews.

THE FADED JACKET OF GRAY........Declamation by Master J. Milton Fain.

LITERATURE....................Composition by Miss Lucile M. Malone.

SHIP ON FIRE.....................Recitation by Miss Nida Boaz

MUSIC—DURO WALTZES—DUETT.

MUSIC—MERMAIDS' SONG...........................Vocal Trio.

LITERARY ADDRESS BY
HON. SEABORN WRIGHT,
OF ROME, GA.
MUSIC—CLAYTON'S MARCH.

MUSIC—ROSE BUSH..Vocal Solo.

PRESENTATION OF MEDALS BY HON. W. R. RANKIN, CALHOUN, GA.

CLASS FAREWELL.

TIMES JOB PRINT, CALHOUN, GA.

The program for Gordon County University's first commencement in 1884 includes the names of several boys and girls who went on to become prominent citizens. (Courtesy of Jane Powers Weldon.)

CLOSING EXERCISES

(PRIMARY AND MUSIC DEPARTMENTS)

Calhoun Normal College

Friday Evening, May 24, 1901.

Welcome...School
Hoffman's Grand March Ethel Richards and Janette Reeve
When the Violets Bloom AgainVeda Haney
Minuet de Mozart........Nannie Dover
Under the Old Umbrella...................Allene Dyar and Jule Neal
Nordische Klange...........................Alma Benson
Murmuring Sea...,.................... ...Estelle and Nannie Dover
Lazy John—comic...,......Master Phil Reeve
Good-Night Drill.
Come, Buy My FlowersEthel Richards
Oh! What Delight..................Ida Harlan
Trio from Schubert...........Nannie Dover, Zella Hall, Veda Haney
Little Blind Match Seller.........................Janette Reeve
Mrs. Brown's Mistake—(comic)Amy Dover and Gussie Brown
Market Day—Operetta.
Queen of-the Fairies.......................Ora Ashworth and Estelle Dover
Asleep at the SwitchZella Hall
Red Riding Hood Drill.
Housekeeper's Complaint—(comic).....................Ora Ashworth
Driven From HomeNannie Dover
Gypsy Scene.Bessie Hughey and Gallagher Neal
Mulligan Guards.
Sailing in the Bright Moonlight.......... Minnie Johnson and Bertie Mills
Sweet Bird of Song.. Zella Hall
Hot Time, Mr. Johnson—(comic)........................James Reeve
Woodland Whispers...........Minnie Johnson and Ethel Richards
Queen Flora—Operetta.

Calhoun Normal College's primary and music departments held closing exercises in May 1901. The participants varied in age, so this is not a graduation program. (Courtesy of Jane Powers Weldon.)

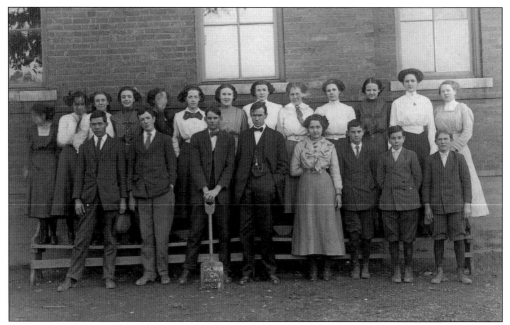

In 1910 or 1911, eighth graders stand with their teachers at the side of the College Street School, then the city's only school and so simply Calhoun School. The brick building at the time served as both elementary, or grammar, school and high school. It was erected about 1902 at a cost of $6,000.

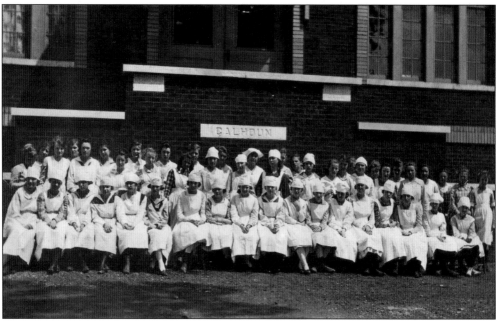

This group of students in Moina Shackelford's domestic science class at Calhoun High School graduated about 1920. The instructor is standing on the back row just below the "O" in Calhoun. Domestic science studies later were called home economics, then more commonly family and consumer science or human ecology.

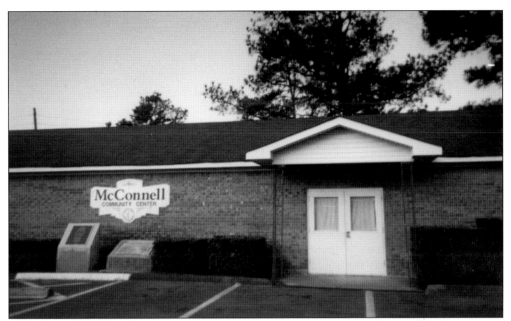

African American children from both city and county attended Stephens School from 1929 until local schools were integrated in 1967. Built with support from the Rosenwald Foundation and townspeople, the school was named for Rev. W.P. Stephens, an early principal. After school integration, the building became an elementary school and later a community center for the McConnell Road and West Side neighborhood. (Courtesy of Maude Chattam.)

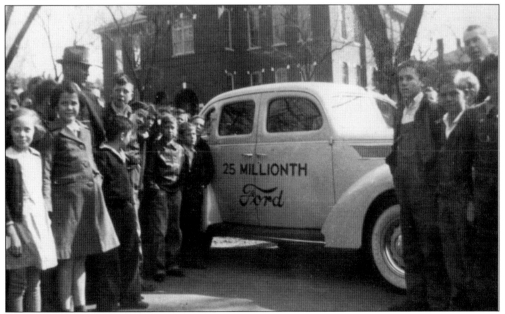

On a tour around the country, the 25-millionth Ford automobile, a deluxe Fordor V-8 trunk sedan, visited Calhoun in 1937. Here, surrounded by admiring children, it parks in front of the old Calhoun School on College Street. Ford said its 25 million automobiles were "enough to transport the entire population of the United States." They would have been crowded, for the population in 1937 was almost 129 million.

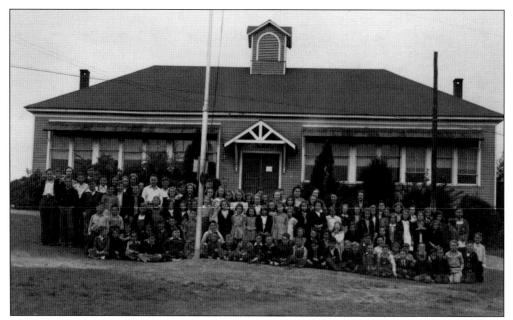

The Echota cotton mill in 1924 opened a school for children living in the 150 houses of the mill village. The four-teacher school stood on a hill overlooking the village and mill. In 1939, students are assembled in front of the school. After it closed in 1960, the children attended city schools and the building was incorporated into the Echota Baptist Church. (Courtesy of Glenese Rogers.)

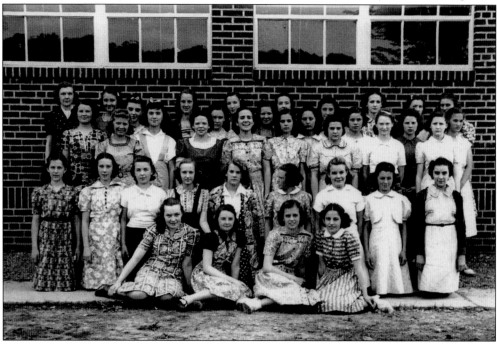

Young women in the Calhoun High School Tri-Hi-Y Club pose for their annual photograph in 1941 on the south side of the high school building demolished in 2014 on Oothcaloga Street. The group includes members of the junior and senior classes. Many of the young men of those classes were the future fighters of World War II.

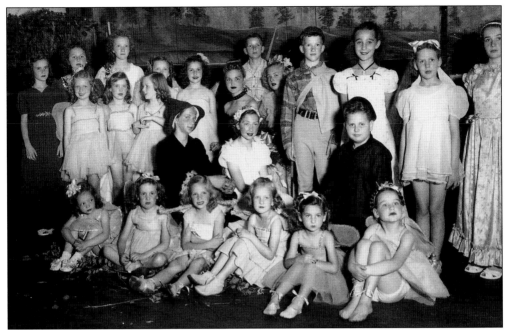

Calhoun Grammar School students perform at the Calhoun High School auditorium in 1947. Such plays were a popular diversion in the mid-20th century, when the school system employed both an "expression" and a music teacher who conducted classes and gave private lessons. One participant in this play remembered making costume wings of bent coat hangers, netting, and glitter.

Calhoun High School students who are members of the Journalism Club are gathered in front of the school in 1949. They were working on the yearbook. Initially called *Echota Echoes*, the annual publication is now the award-winning *Jacketeer*. The 1930 edition of *Echota Echoes* includes six faculty members, including Miss Ethel Thompson, who taught three generations of students.

Bandmaster Frank Baker took a few of his charges from the high school to give a St. Patrick's Day program for the Rotary Club in 1950. The school's band marched for football games, played at pep rallies, and entertained civic clubs. Baker had been a member of Ringling Bros. and Barnum & Bailey's circus band. Calhoun High's music programs have won many district and state awards through the years.

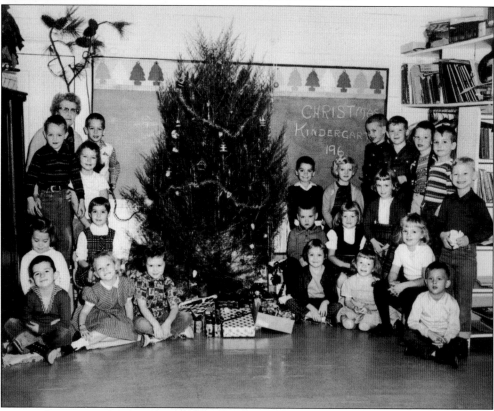

During the 1950s and 1960s, many Calhoun children started their schooling in kindergarten at Oakleigh, later home of the Gordon County Historical Society. Ruby Brown, left rear, taught the children to prepare for school and life. The class here enjoys a Christmas party in 1960. The kindergarten's annual Tom Thumb wedding was large enough to be held in the high school auditorium.

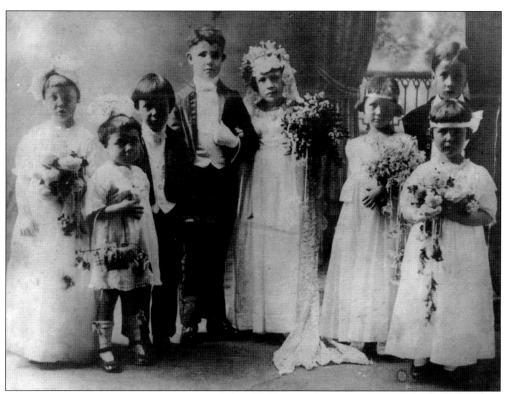

A highly anticipated annual event was a Tom Thumb wedding, which began in Calhoun long before Mrs. Brown's kindergarten. In 1915, above, a wedding sponsored by the Calhoun Woman's Club includes, from left to right, Helen Henson, ? Mason, Clay Fossett, C.B. David, Sara Erwin, Arva Watts, Clay Fox, and Frances Dorsey. LaBelle David and Thomas Herrin Bond, right, are bride and groom in 1936. LaBelle went on to marry Bert Lance and travel with him to the Georgia state capital and to Washington, DC.

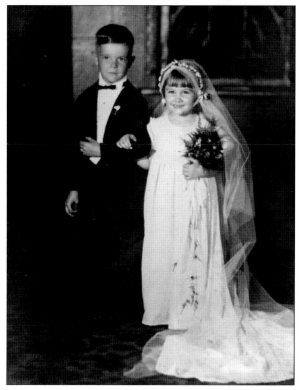

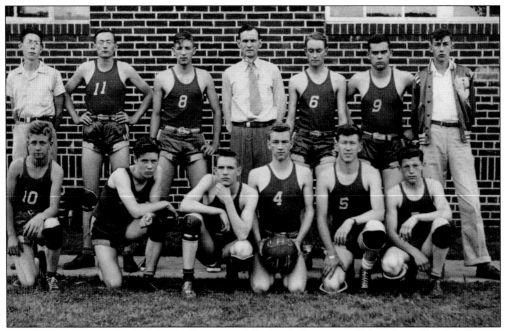

Coach McEntire, center, led the Calhoun men's basketball team in 1944. They played in the old wooden gymnasium in space later occupied by the Phil Reeve Stadium ticket office. Girls' and boys' basketball were already important sports during the 1930s and 1940s. Geraldine Legg was the girls' coach for several years.

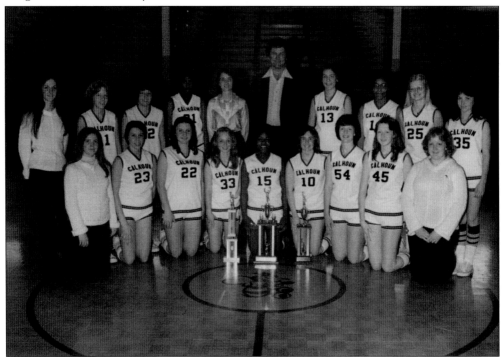

This Calhoun High School girls' varsity basketball team with Henry Leslie as coach won the regional championship in 1978 and went on to state competition. (Courtesy of Helen Jane McDonald.)

The Calhoun High School Yellow Jackets football program has enjoyed strong community support since its inception in the 1920s. In the early 1950s, players gather around Coach Jerry Deleski, who explains strategy to the attentive group. The fall after the last of these players graduated, in 1952, the team won its first state championship game.

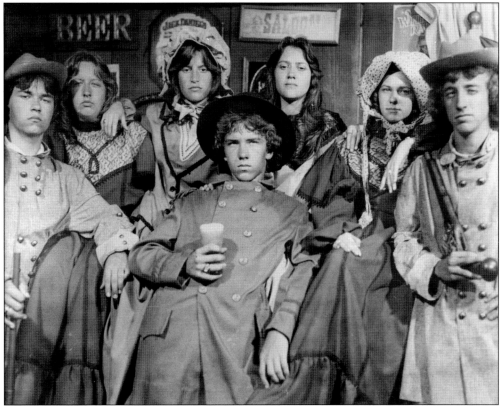

Some would-be high school dramatists in Civil-War–era costumes pose in this photograph snapped in 1974. The Calhoun High School drama department has dominated statewide competitions for many years, beginning in the 1960s when Sandra Worthington Silvers directed the plays. The tradition continued as students of Julie Owens Leggett won at regional and state levels. (Courtesy of VG gor049.)

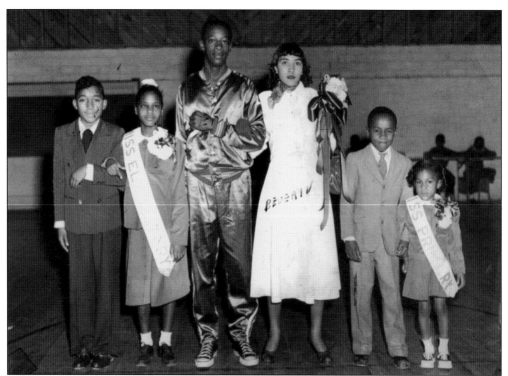

Stephens School, the city and county's only school for African American children during segregation, sponsored a group called Queens. Queen Beverly McDowell, 1951, poses in the school gymnasium with her attendants and their escorts. They were, from left to right, Acie McDowell, Miss Elementary Marie Perry, E.Z. McDaniel (wearing his basketball warm-up suit), Beverly McDowell, Larry Steele, and Miss Primary Mary Ruth Simpson. (Courtesy of Mary Ruth Simpson Garrigan.)

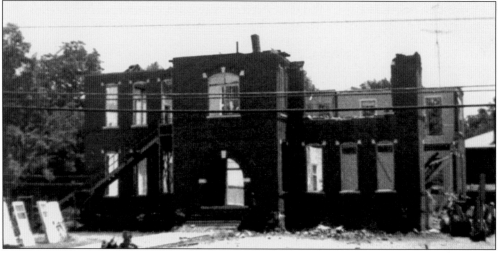

Hearts were heavy in Calhoun when the old College Street School was demolished in 1974. The building had a central tower with a bell that rang a warning first bell and last bell to summon children to school each day. The demolition marked the end of secular education at the site, where school buildings had stood since the late 19th century.

Five

GOOD OLD
GOLDEN RULE DAYS

Since the time of the Cherokees, religion has played a major role in the life of Calhoun's citizens. Moravians operated a mission at Oothcaloga, in the southern part of the county, from 1822 until 1833, when a white family moved into the house following the land lottery. At New Echota, the Congregationalists, in Georgia called Presbyterians, established a mission, and Methodists, too, had a presence among the local Cherokees. Christians fell from favor, however, when the Native Americans came to believe that they approved removal.

Even before there was a Calhoun, there were churches in the region. From 1822, the earliest Baptists were joined by Methodists, Presbyterians, Cumberland Presbyterians, and Episcopalians, who built houses of worship that attracted the faithful. Evangelical groups came later and stayed as a strong presence in the local religious community. Seventh-day Adventists built an academy well known throughout the Southeast.

Early, informal places of worship included brush arbors—large, outdoor structures with open sides and brush or tin roofs. They were surrounded by tents, simple cabins with canvas roofs and screened walls, where worshippers lived during annual camp meetings.

More permanent structures of wood, rock, and brick sprang up as the population increased. Some burned or blew away; some had rough use by troops during the Civil War; some were enlarged or replaced as congregations grew. Some died as congregants left—or died. But a drive on a Sunday morning, or a Wednesday night, or almost any other day, will show that the winds of faith have not died in the hills and valleys of northwest Georgia.

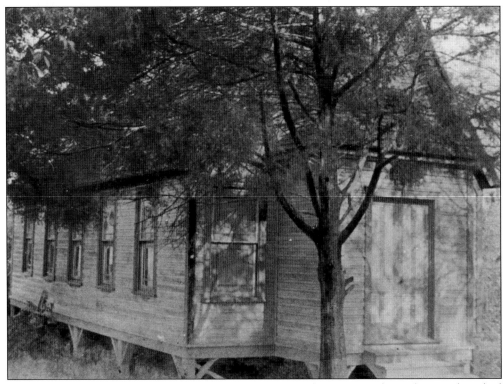

St. James's Episcopal Church held its first services in 1893 in this structure that Lulie Pitts described as "a one-story wooden building of chapel design, finished neatly inside, having a seating capacity" of about 200 and a "sweet-toned reed organ." According to the Vanishing Georgia collection at the Georgia Archives, it stood at the corner of Wall and Hicks Streets. Among its early supporters was the family of Nellie Peters Black. The children below have just performed in a carnival sponsored by the church. After the St. James congregation dwindled, the church was razed for a commercial building. A new Episcopal congregation, St. Timothy's, was organized in 1974. Originally meeting on South Wall Street, after six years the congregation moved to the rock First Presbyterian church building on Trammell Street when the Presbyterians moved to Red Bud Road.

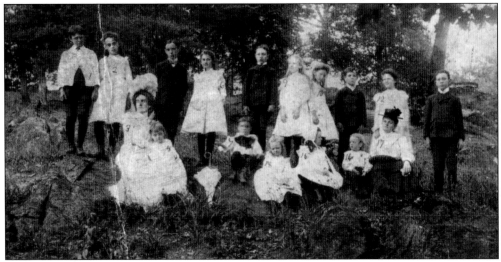

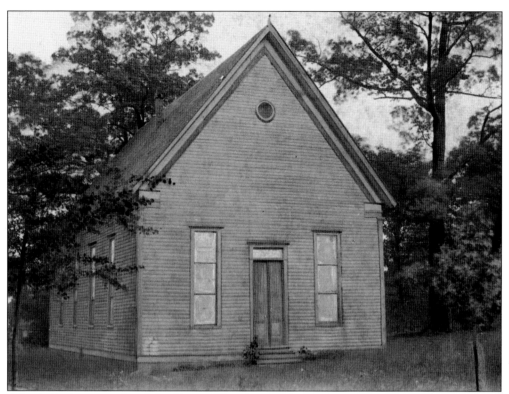

A brick Presbyterian church had been all but destroyed in 1864 when Federal troops camped on the grounds and stabled their horses in the church. This replacement, above, was used beginning about 1889. W. Laurens Hillhouse began the rock church, below, in 1921; it stands across the street from his own home, of similar local rock construction. At the time it was built, the *Calhoun Times* described the church's "strength and simplicity" as "stately and upright and durable as the hills." The location's use for a house of worship continued after the Presbyterians built a new complex on the Red Bud Road. St. Timothy's Episcopal Church moved to Trammell Street, into the old rock church property originally donated by the family of Gordon County historian Lulie Pitts.

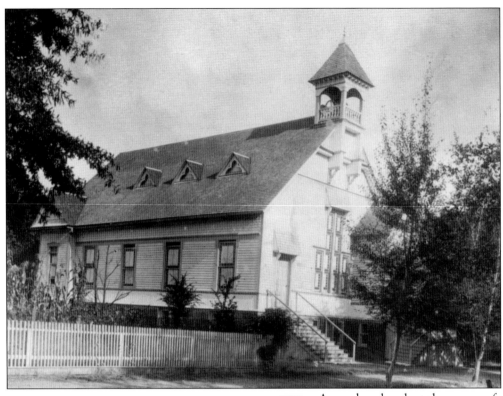

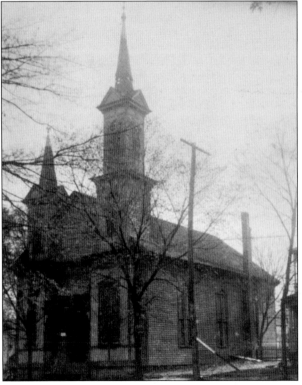

A wooden church at the corner of North Wall and Trammell Streets (above), photographed in 1920, was the house of worship for Calhoun Baptists from 1889 until it was razed in 1921. Its nearby neighbor on Wall Street was the twin-steepled Methodist church, also wooden, shown here in 1918. The three downtown churches, Baptist, Methodist, and Presbyterian, had a history of ecumenical cooperation when one or another had a building crisis. For several decades around the middle of the 20th century, the three sponsored consecutive Vacation Bible Schools each summer. Children of all three denominations attended one after the other to help pass long summer days in a small town with few diversions.

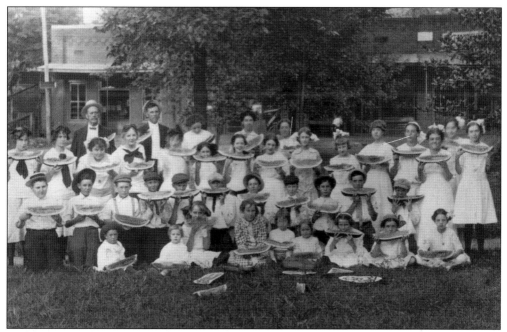

Children enjoy watermelon provided by the First Baptist Church in 1914. They walked the two blocks from the church, probably for Vacation Bible School, and sat on the grass of the Ladies' Park with their backs to businesses on Park Avenue. M.L. Keith was the pastor at the time. (Courtesy of the City of Calhoun.)

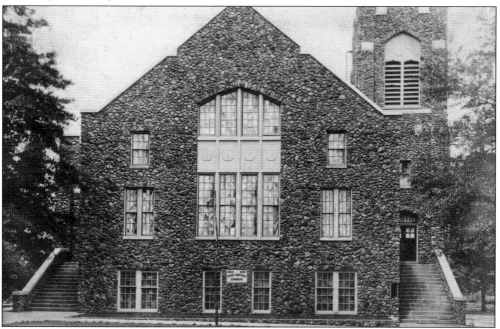

The church erected by the Baptists in 1922 stood foursquare to North Wall Street. On the back of this postcard, mailed in 1923, Laurens Hillhouse writes to "Miss Bai" Hall about the "grand day yesterday laying cornerstone" in the empty place visible to the right front of the building. It was 20 years before the congregation celebrated retiring the debt on the church.

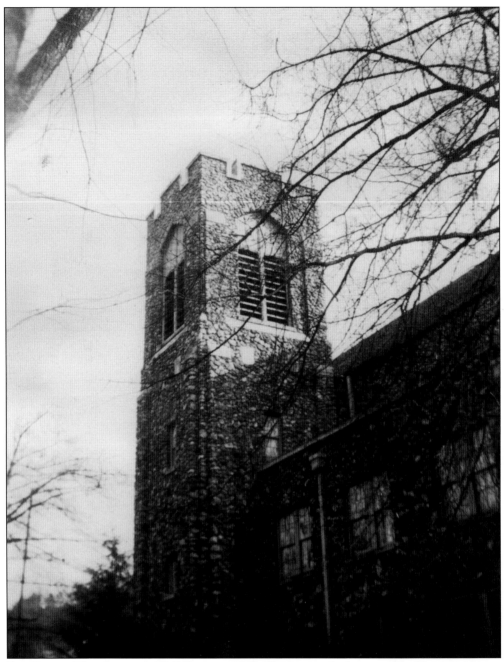

First Baptist Church rose on Wall Street in 1922. The lot on which it stood had been the home of Baptists since the 1870s. Union soldiers had wrecked an earlier church in a different location. The rock church cost $41,000 to build and seated more than 1,000 worshippers, according to Lulie Pitts in her history of Calhoun.

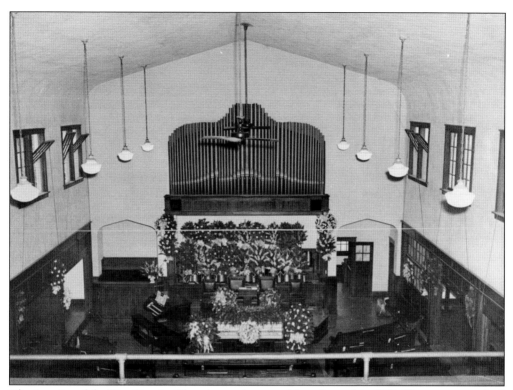

The interior of the First Baptist Church was decorated for a funeral in 1952. The pipe organ had originally been in a theater but found a place in a private home after the church moved to a new building. Erskine Caldwell, author of *Tobacco Road*, reportedly worked on the building when an uncle was a contractor. (Courtesy of VG gor032.)

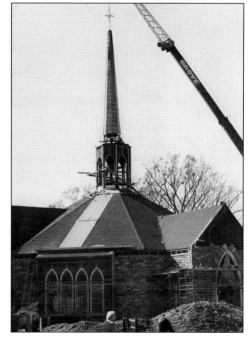

Several generations later, leaders decided to build a new church on College Street, on the site of the old College Street School. The new church, built of fieldstone, rises in 1975 where generations of Calhoun children studied in the old brick buildings and frolicked on the playgrounds. The church celebrated its centennial in 1952.

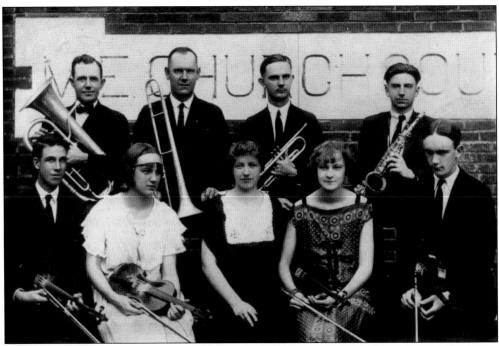

The orchestra of Calhoun's Methodist Episcopal Church, South, gathers in front of the church in 1922. Members included Phil Reeve, back row, third from left, a businessman who played with and managed old-time musicians the Georgia Yellow Hammers. Georgia Public Television recorded his wife, Jewell, center, front, playing ragtime piano when she was well into her 90s. Orchestras and choirs were an important part of church life. Bands have replaced orchestras in many churches, but the choirs continue to lift their voices in worship. In 1933, Lulie Pitts wrote of the Calhoun church, "a music director is employed regularly and standard choral selections rendered by talented members feature [sic] the services." The First Methodist choir, in 1944, sang before stained-glass windows that were moved into a more modern church in 1950.

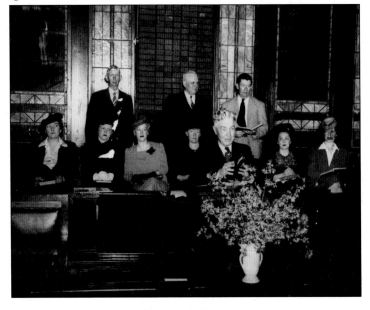

One Methodist baritone did double duty when photographs were made in 1944. Choir member and steward Lawrence Moss is seated third from the left in front. Officials were, from left, A.B. David, T.J. Lance, Moss, Pastor Robert Armour, T.J. Brown, and W.F. Bond. The clock faces the preacher, a not-so-gentle reminder that someone's roast beef should come out of the oven shortly after noon.

Planning for the Methodist church on North Wall Street, just a block south of First Baptist, began in 1919 when the congregation outgrew its wooden building. At the time, the denomination in Georgia was known as the Methodist Episcopal Church, South. Later simply Methodist, the denomination eventually joined the Evangelical United Brethren in 1968 to become the United Methodist Church; the Calhoun church remained a part of the parent denomination.

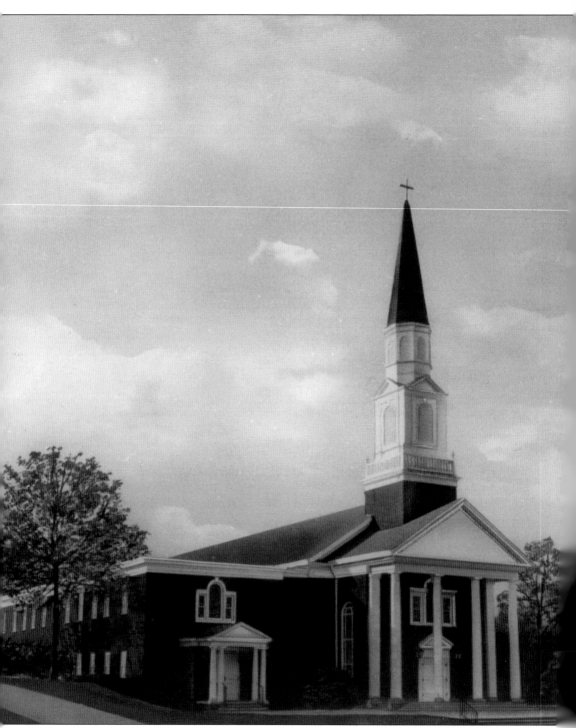

First Methodist Church moved to Line Street at the corner of College Street in 1950. Boston Chapel, to the left of the sanctuary, was added in 1967. The new building incorporated many of the historic stained-glass windows that had graced the old church on North Wall Street. The windows were memorials to the church's founders and early leaders.

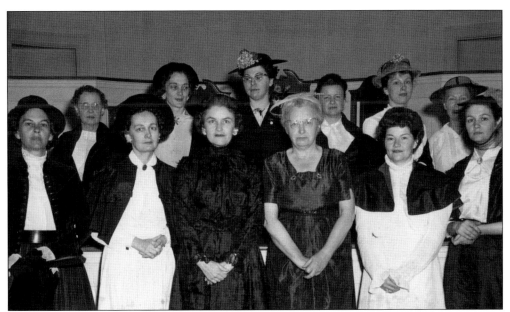

In the mid-1950s, women of First Methodist presented a program to celebrate the church's centennial. This group donned costumes to represent the founding mothers and gave an afternoon of readings and song. They stand in the sanctuary that was dedicated and occupied in 1950.

Note singing is a musical tradition based on late 18th-century Sacred Harp, or shape note, singing. It is organized around yearly classes that travel to all-day singing conventions. A local group, for example, traveled in 1980 to the Tennessee-Georgia Convention for performances in several Georgia counties and Chattanooga, Tennessee. These singers pose in the 1960s, probably on the steps of the old Allen Chapel AME church. (Courtesy of Celia Clemons.)

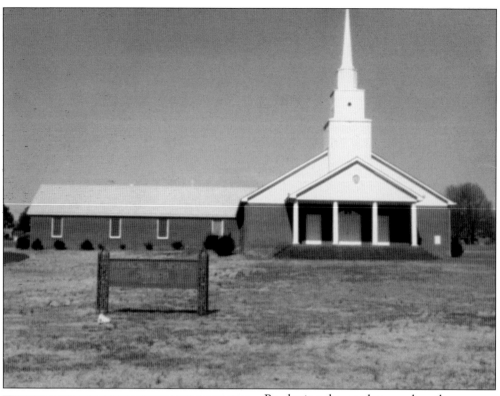

Bracketing the northern and southern boundaries of Calhoun in the 20th century were Echota Baptist Church, near the cotton mill and village, and Belmont Baptist, pictured here in 1976, in the neighborhood called Rock City. The Belmont church was founded in 1950 with 30 charter members.

To the west were the African American congregations of Allen Chapel AME, pictured here, and Friendship Baptist. Allen Chapel African Methodist Episcopal (AME) Church has served in Calhoun for many years. Friendship Baptist was established by the mid-19th century and had a permanent building by 1882. (Courtesy of Janie Aker.)

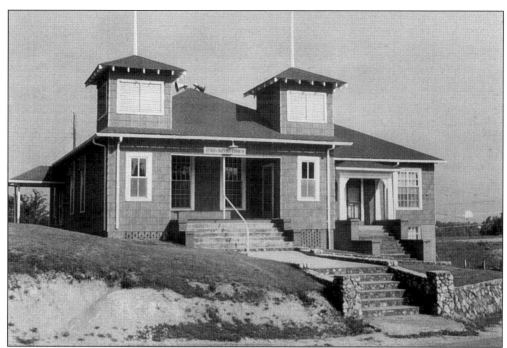

Echota Baptist Church had its beginnings on the then-northern boundary of Calhoun in 1924, the same year the cotton mill opened the school and company store. After Echota School closed, the church acquired and remodeled its property. Following a few years of worship there, the congregation added a new sanctuary wing in 1967. They continued to use the old church, visible to the right behind the new sanctuary, for Sunday school.

In 1975, the Georgia-Cumberland Conference of Seventh-day Adventists established its headquarters in Calhoun. The local presence also includes a church and worship center on the Rome road, Georgia-Cumberland Academy at Reeves Station, and Gordon Hospital in Calhoun. For several years, the congregation worshiped at this building, now a bank, on Highway 53 West, before moving to its larger facility.

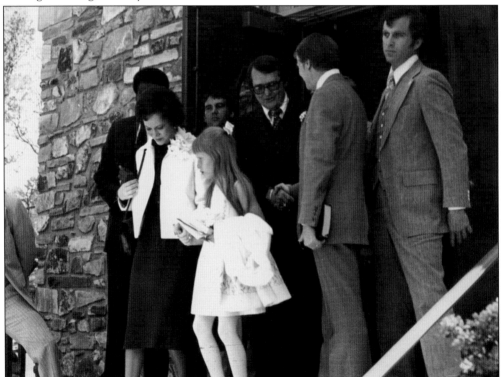

Pres. Jimmy Carter, his wife, Rosalynn, and daughter, Amy, spent the Easter holiday in Calhoun with family and friends in April 1977. Here, they leave worship services at First Baptist Church. The president (second from right) speaks with the Rev. Bob Maddox. Rosalynn and Amy are to the left, and Calhoun native Sam Edwards, one of Mr. Carter's front men, looks over Amy's head. A secret service man lurks to the right.

Six

TAKING CARE OF BUSINESS

The economy of Calhoun started with agriculture and stretched through the years to include spinning, weaving, tufting, and heavy industry, supported by highways and railroads.

Small farmers grew cotton along with food crops until the boll weevil consumed the economy of the South and drove the region into the despair of the Great Depression. Desperate women turned the traditional handicraft of candlewicking, a style of textured embroidery, into a source of income for their families; frequently their children and idle spouses learned to help. Highway 41, where colorful chenille bedspreads hung along the roadsides, was called Peacock Alley by Midwestern tourists on their way to Florida's sunshine. They bought the blankets and spread the word. As the home trade grew into industry, railroads carried the cotton goods north to larger markets.

Local entrepreneurs doubled the width of looms to make broadloom and, using principles of tufting, began manufacturing carpet and other fabric goods. Calhoun was part of the enterprise that made nearby Dalton the "Carpet Capital of the World." The carpet business broadened into other flooring and solid surfaces, which, if not manufactured locally, were warehoused in Calhoun and distributed all over the world.

Calhoun has been a transportation center since its beginning. Cherokees and early settlers used its trails and rivers for travel, transport, and food; the Dixie Highway provided access to the South and North for vacationers and commerce alike. The state-built Western & Atlantic Railroad bisected the county, and I-75, when it was completed in 1977, became a major corridor between Atlanta and Chattanooga. National and international business brought about a well-regarded regional airport.

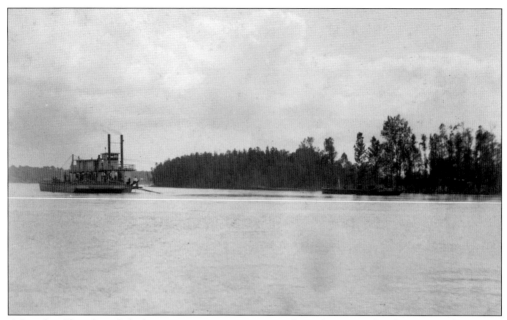

After the Cherokees left the area, commerce among whites began to develop on roadways and waterways. The business of agriculture brought barges that transported cotton and other agricultural products downriver in the 19th century. The Oostanaula, Gordon County's largest river, flooded regularly until Carter's Dam was built. In this 1886 photograph, a steamboat attempts to navigate the Oostanaula at flood stage.

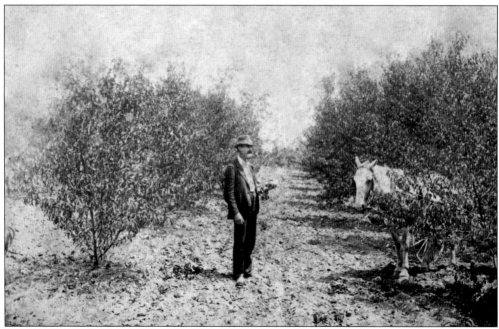

W.L. Hillhouse stands in an orchard in 1892. He noted on the back of this photograph: "W.L. Hillhouse & old Knox on Mt. ? east of the 'shanties' on the W.&A. RR north of Calhoun 3 miles." Hillhouse and his horse were visiting an orchard that was one of many around the city in the late 19th century. Another was the Harbin orchard on Mount Alto.

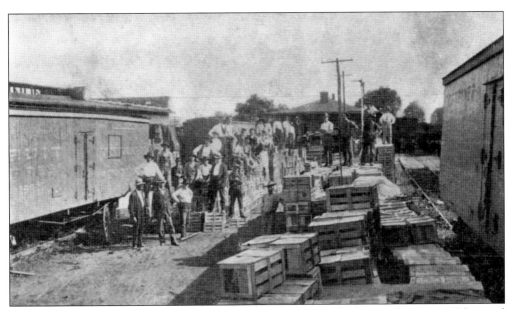

Even in northwestern Georgia, peaches were a viable crop in the late 19th century. Of several varieties grown in Calhoun, the Elberta was best for shipping. The peach boom in Calhoun was short lived after a market glut depleted demand. Cotton was king, however, as it was in the rest of the state. The year after the boll weevil hit Georgia in 1913, cotton production was reduced by half but continued, though on a lesser scale. Until production was depressed by agricultural and economic factors, both crops were shipped north from the Calhoun depot. In the above photograph, crates of Elberta peaches await shipping on the platform at the depot in 1908. Boxes of textiles, below, were still going out in 1944.

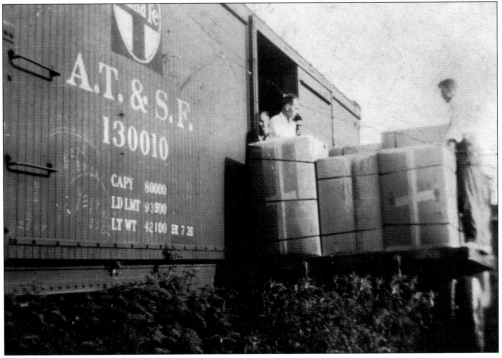

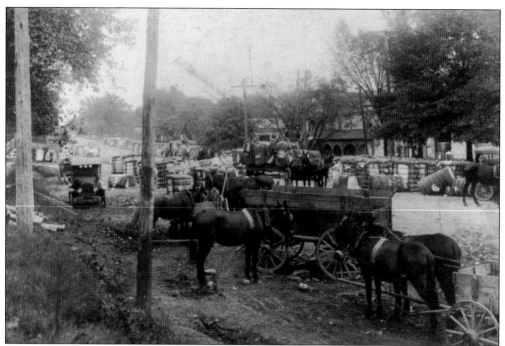

Mule wagons, their drivers, and bales of cotton choke Court Street at the corner of King Street in the early 20th century. The cotton has been ginned and baled at a nearby establishment and waits to be hauled away, some of it to the rail depot just around the corner.

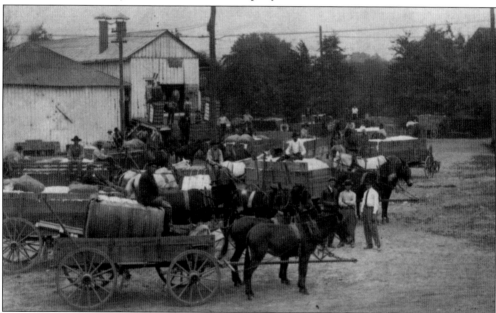

The Johnson Gin Company, west of the railroad tracks in downtown Calhoun, burned in 1943. Some of the cotton in this photograph has been baled, but several wagons-full still wait to be fed into the gin for processing. The cotton would have come from small farms around the county. After falling off for some years, cotton production in Georgia was on the rise in the early 21st century.

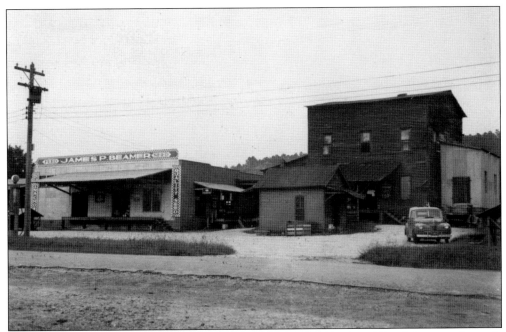

Another gin near the railroad was beside James P. Beamer Feed and Seed, here in the early 1940s. As late as that period, county schools recessed for about two weeks in the fall to allow children to help with picking cotton. The back-breaking labor gave way to automation only a few years later.

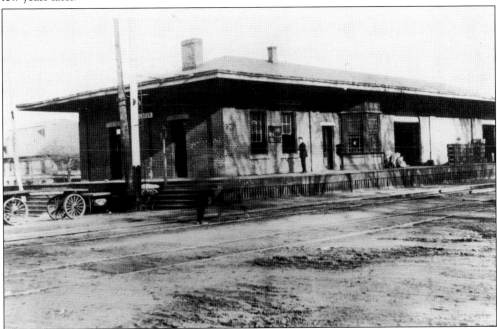

A lone man stands on the platform of the Calhoun depot in 1910, when trains stopped in town for both freight and passengers. The state-owned Western & Atlantic Railroad is now leased to CSX and is strictly a freight carrier. Voters selected Calhoun to be the county seat partly because of its situation on the railroad. One of the town's original names was Oothcaloga Depot.

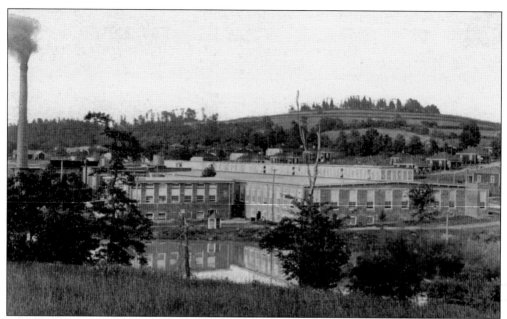

Echota Cotton Mill was one of Calhoun's earliest industries. Located on the north end of town, the mill was organized in 1907 and began milling in 1909 on land that had been the Gordon County pauper farm. By 1920, it employed 300 operatives. A village adjoining the mill furnished 150 houses for mill employees. The business became Mount Vernon Mills in 1971 and is now defunct. Only the chimney still stands next to another business on the property. In 1924, the same year the Echota School began, mill management opened a cooperative store.

THE COMPANY STORE

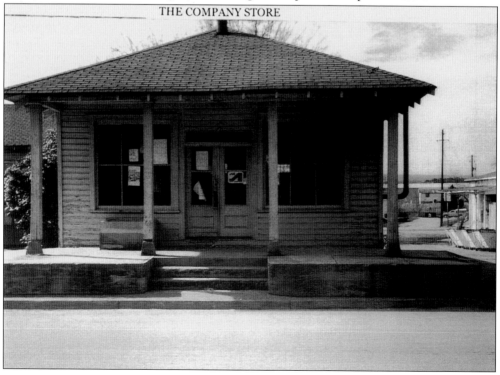

Nellie Peters Black (1851–1919) was the daughter of Richard Peters, financier in Atlanta and landowner in Gordon County, and the wife of Ralph Black, a businessman, experimental farmer, state legislator, and congressman. After his death, she worked from Atlanta in her family's effort to manage the large Peters farm. Among her many progressive interests was a campaign for Georgia farmers to diversify and become less dependent on cotton. She was named a Georgia Woman of Achievement in 1996. Ownership of the Peters Farm went from the family to friends Burton J. and Willie Bell. It finally became a residential development at the southern side of Calhoun. Gus Boaz caught an image of the farm after a heavy snowfall in 1931. (Above, courtesy of VG gor187.)

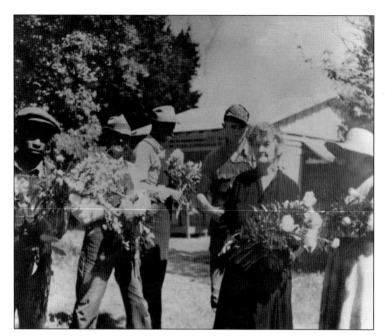

Minnie Bray Jones was another businesswoman who farmed. Living at the old Bray homestead, known as the Daffodil Farm, she raised daffodils and other flowers to ship from Calhoun to buyers across the eastern United States. Here, in the 1930s, she and farm workers hold armfuls of peonies to be shipped. The old homestead at Daffodil Farm is surrounded every spring by acres of beautiful yellow flowers.

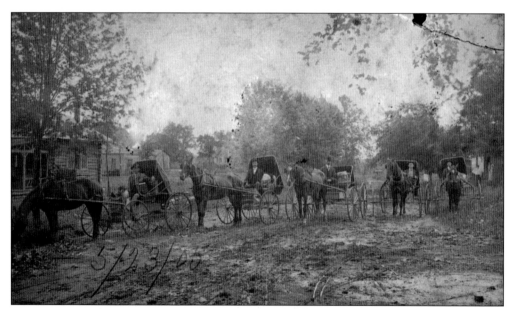

Georgia's own Thomas E. Watson began pressuring his colleagues in Congress for rural free delivery mail three years before the government initiated it in 1896. Before then, people living in the country had to travel into town to pick up their mail. Calhoun's first rural mail carriers are loaded and ready to deliver in 1905 on Railroad Street, now Park Avenue, near the Woman's Club cabin.

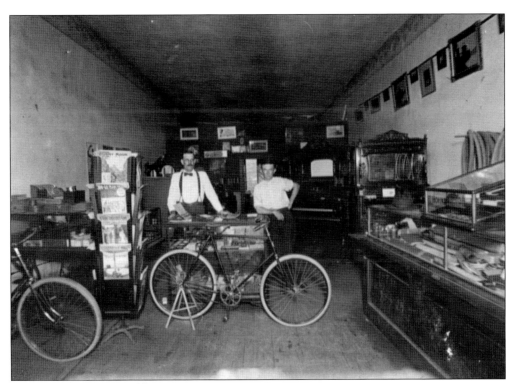

Lawrence Moss, left, and his stepson Phil Reeve stand in the L. Moss Music Company on South Wall Street around 1913. Moss founded the business that sold organs, pianos, sheet music, sewing machines, bicycles, and bicycle parts. Reeve was a member of the Georgia Yellow Hammers and, about 1926–1928, was the business manager for the group as well as the Afro Cherokee music duo Andrew and Jim Baxter, yet as late as 1940 a bench in front of the store was still designated white only.

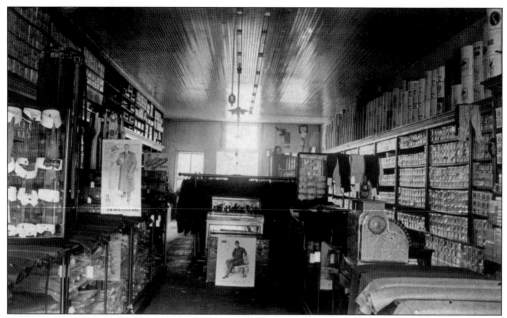

Posters in A.R. McDaniel's store, probably around the turn of the 19th to 20th centuries, depict outfits for the well-dressed gentleman of the period. Two cases hold stiff celluloid collars, which were worn over dress shirts. They could be removed and wiped clean without the time and labor of laundering, starching, and ironing the entire shirts. The tall, round boxes on high shelves to the right hold hats.

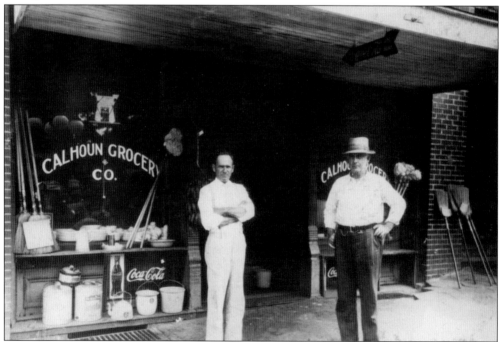

J.W. Phillips, left, and Sam Boston stand in front of the Calhoun Grocery Company on Court Street about 1944. At the time, there were several small grocery stores in the town, each providing a variety of merchandise generally associated with housekeeping and cooking.

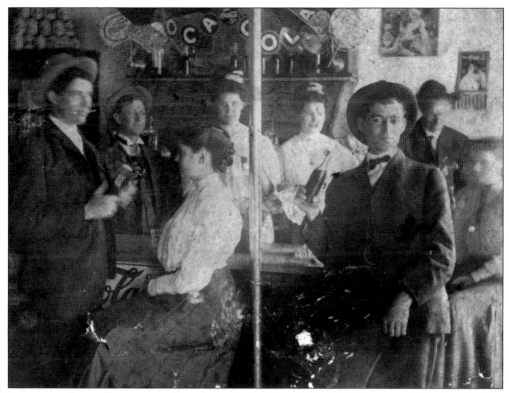

Banners and a small poster proclaim the arrival of Coca-Cola in Calhoun, probably shortly after 1899, the year two Chattanoogans obtained the rights to bottle the drink throughout the United States. Dressed for the occasion, young women and dandies enjoyed the product at Jesse Johnson's dry goods store. The familiar contoured bottle was not introduced until 1916. In 1910 the store, below, still had a soda fountain at the front with ice-cream tables for adults and children alike. A hardware store followed this establishment at the same location, the northeast corner of Court Street and Park Avenue, originally Railroad Street.

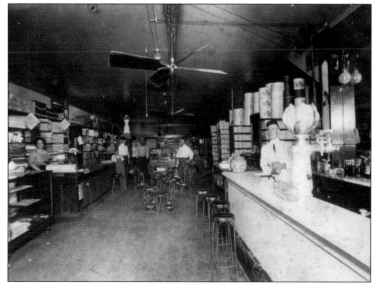

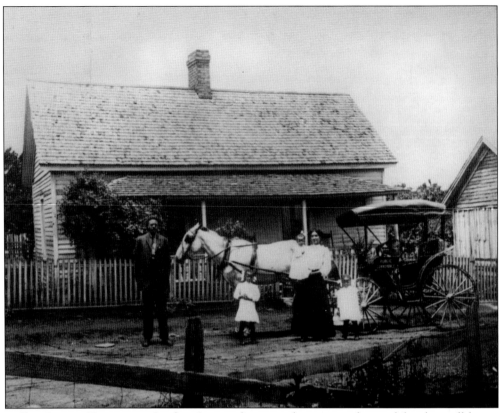

Willie "Buster" Hunt was a Gordon County farmer and ancestor of several families still living in the area. In this photograph from 1912, he stands with the horse and buggy that provided taxi and delivery service for the city and county. His wife, Willie Belle, is standing with him and their children. Their daughter, also named Willie Belle, married Roy Chattam. (Courtesy of Maude Chattam.)

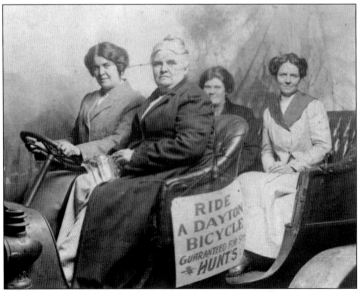

The Rooker sisters, here in the early 1900s with their Grandmother Barnett in the front passenger seat, never learned to drive a car. They were not shy, however, about sitting in a demonstration model that interestingly advertised Dayton bicycles. They were proprietors of a business that depended heavily on automobile traffic, the Hotel Rooker, which is now the home of the Harris Arts Center.

Salesmen, no matter how they traveled, were an important part of any business transaction. Two drummers, as they were also called because they drummed up business, came to Calhoun in a horse and buggy in 1901. They drove "the loop," a two-day trip from Calhoun to Resaca to Red Bud to Fairmount to Calhoun. A third drummer arrived by rail at an undetermined date and showed off a bit at the depot. The hand truck behind him held products waiting to be shipped. All the men might have stayed overnight at one of the hotels or boarding houses lining the street beside the railroad tracks. (Right, courtesy of Dr. Larry Davis.)

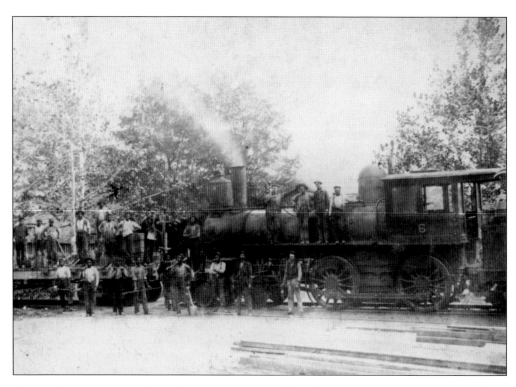

Gordon County historian Lulie Pitts wrote that in 1883 "all animals were given the right-of-way through the streets." That situation changed with the coming of automobiles, which, as they became more numerous, needed help crossing the railroad tracks and negotiating muddy streets. A work crew from New York, above, works on the railroad crossing at Court Street in 1900. A later project involved paving the streets, here, Court Street at South Wall, looking south, in 1917–1918. Pedestrians probably appreciated some assistance, too.

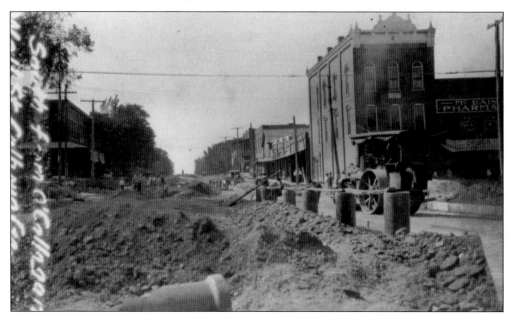

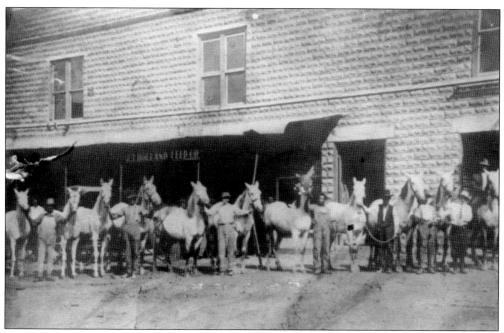

The J.W. Logan Livery Barn, above, was operating in 1907 on Park Avenue, then named Railroad Street, conveniently adjacent to the J.L. Holland Feed Company. The barn is said to have provided a matched team of horses for the funeral in Rome, Georgia, of Ellen Axon Wilson, first wife of Pres. Woodrow Wilson, when she died in 1914. By 1941, J.W.'s son Patsy operated an auto parts and repair service in the same building. He was also a boxer whose prizefight is featured elsewhere in this volume. The reverse side of this photograph is inscribed "To My Ole Sparring Partner, Patsy Logan, ? 10, 1961." (Below, courtesy of the City of Calhoun.)

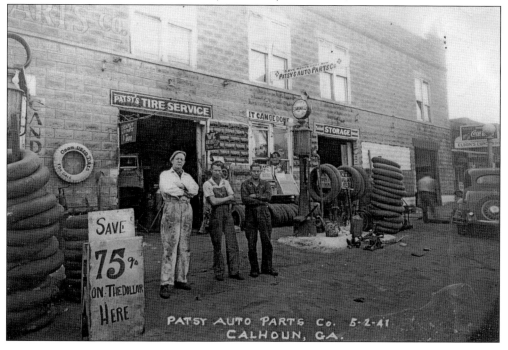

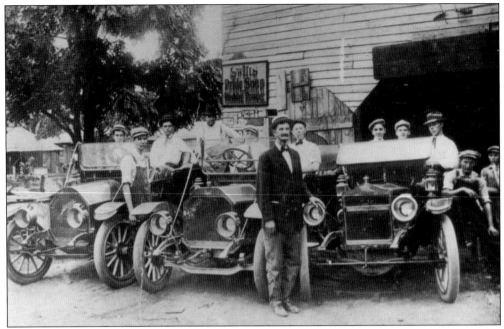

The first Calhoun Garage operated on South Wall Street from the early 20th century until it was razed in 1935. John Ray, center, with mustache, owned the facility. The automobiles are, left to right, a Mitchell, a Buick, and a Maxwell. The sign on the wall advertises Swifts Pride Soap Washing Powder.

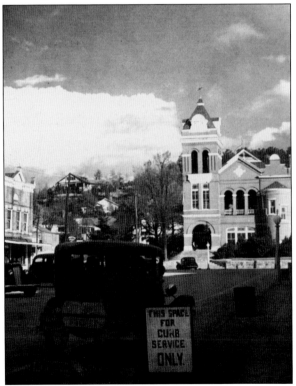

An automobile bearing a sign for Orient Flour parks on Court Street facing east about 1930. The Foster Building is to the left, and the Boston home on Mount Alto looks down on the city. The steps and wall in front of the courthouse were built when the street was lowered for construction of US 41, then the Dixie Highway. The curb service sign may have been for a drugstore.

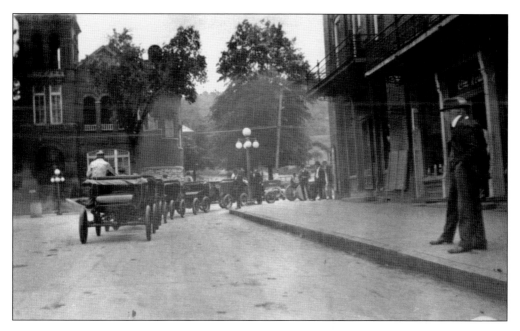

Bystanders, above, watch a procession of new Ford automobiles turn from South Court Street onto South Wall Street as they are being delivered to the Fox Motor Company in the 1920s. After delivery, the cars parked in front of the company for folks who wanted to take a closer look. Model T Fords were available in black, black, and black. James Carl "J.C." Fox opened the Ford dealership in 1913 and operated it until 1953, when he sold the car division. The truck and tractor division changed hands in 1959. In 1956, he bought and operated Amakanata Fish Hatchery, which he operated with his son until 1968.

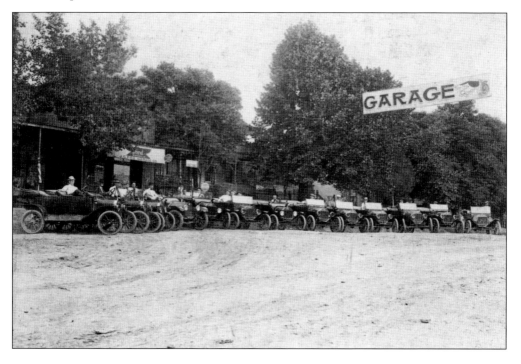

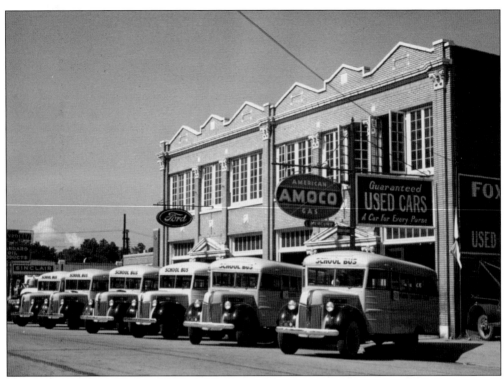

Automotive traffic brought sales and repairs. The Fox Ford Building on South Wall Street sold new Ford automobiles, trucks, tractors, and used cars, and repaired them all. Brand-new yellow buses for the Gordon County school system line up in front of the dealer to be delivered in 1941. Inside, a salesman demonstrated a new Ford tractor for an intent audience of farmers. (Courtesy of Dr. Larry Davis.)

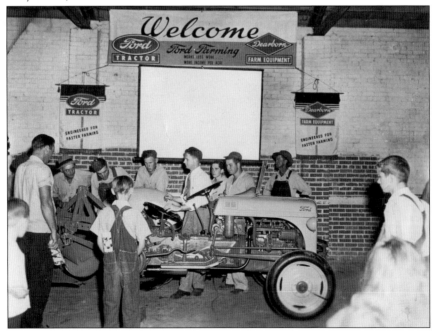

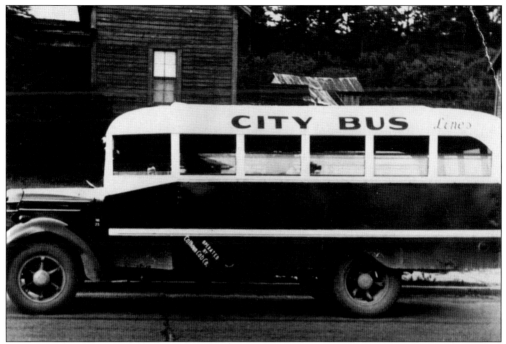

The only bus line Calhoun ever had ran from Motor Aid #6, on US Highway 41 at the northern end of College Street, to Rock City to the south. Driven by Ernest "Buck" Brown, the bus, here in 1944, operated for about two years under the management of the Calhoun Cab Company.

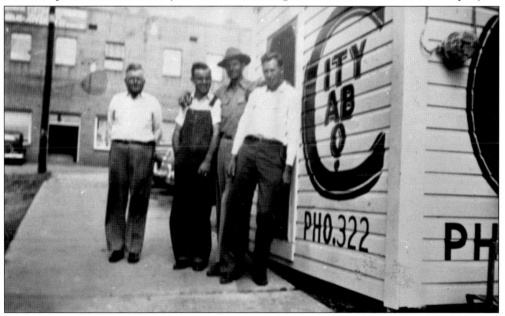

In the late 1940s, four cab drivers pause in front of their stand. The Calhoun Cab Company operated at the corner of Court and Piedmont Streets, across from Lay Hall Grocery Company, visible in the background, in a large, wooden former blacksmith shop. Each driver owned his own vehicle. They are, from left to right, business owner J. Horace Lewis, M.C. Densmore, Winston Edge, and Jack Lowman.

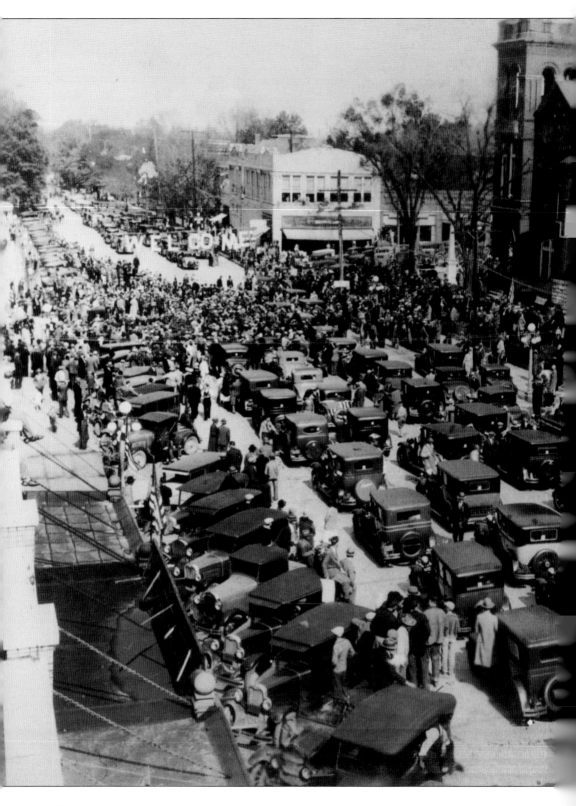

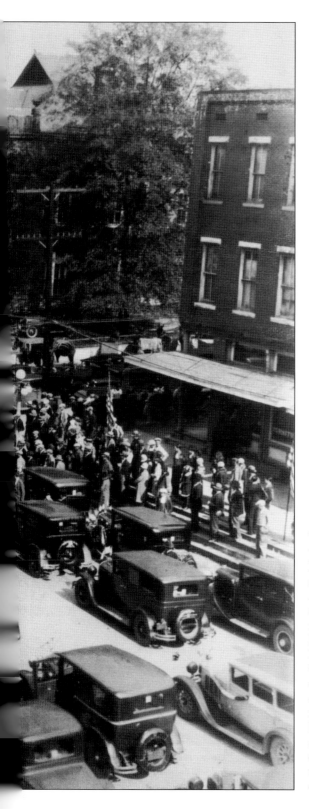

The Dixie Highway, US Highway 41, was planned to be a route connecting Northern Michigan and Miami. Built in segments, the highway opened between Atlanta and Chattanooga in 1929. A crowd of automobiles and people gathers in downtown Calhoun to celebrate the highway's local opening. The camera looks north near the 1889 Gordon County courthouse. After the highway opened and tourist traffic increased, enterprising chenille bedspread makers in north Georgia advertised their wares by hanging the spreads on clotheslines along the route. The colorful roadside displays caused travelers to refer to the passage as Bedspread Boulevard, or, more famously, Peacock Alley.

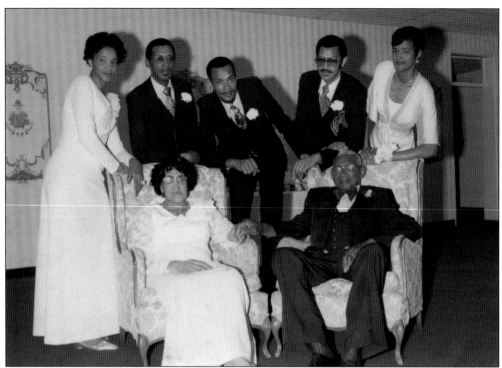

Roy Chattam founded and operated a moving company that the community engaged for more than 60 years. When he retired, his grandson Leroy "Bubba" Chattam Jr. carried on the family business. The five children of Roy and Willie Belle Chattam honored them with a party on their 50th wedding anniversary in 1978. (Courtesy of Maude Chattam.)

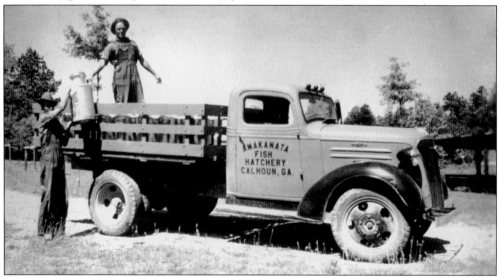

Amakanata Hatchery's trucks delivered live fingerling fish all over the Eastern Seaboard from 1934 until the 1950s. Charlie Cantrell (left) and James Wyatt prepare a shipment in the 1940s. The name Amakanata is coined loosely from the Cherokee words *ama* and *kanati* to mean "Spring of the Happy Hunter." An artesian well feeds the original lake, while other ponds are spring-fed. (Courtesy of Dr. Larry Davis.)

Margie Davis and her husband, Ford, ran Ford's Market on Court Street in downtown Calhoun after World War II. Shoppers who wanted to buy English peas, turnip greens, or pork and beans for 10¢ either walked or parked at the curb and deposited a nickel in the parking meter. The Davises later purchased Amakanata Fish Hatchery. (Courtesy of Dr. Larry Davis.)

An area newspaper wrote in 1948 that "mayor-elect J. Roy McGinty of Calhoun, Ga., throws the switch and changes Calhoun's telephone system from manual to dial as Phil Reeve, president of the Calhoun Rotary Club, and Bob Collins, Rotarian, look on." When the switch was made that year at midnight, January 3, there were 943 stations in service. Telephone numbers at the time went from three to four digits.

A vital part of business in downtown was the Johnston-Hall Hospital, on South Wall Street near the Rooker Hotel. This 1949 view shows a drugstore and gas company in the same building. The facility was founded in 1937 by Dr. Z.V. Johnston, who was joined in later years by many distinguished physicians. It closed in 1950 when the city built a new hospital on the west side of town.

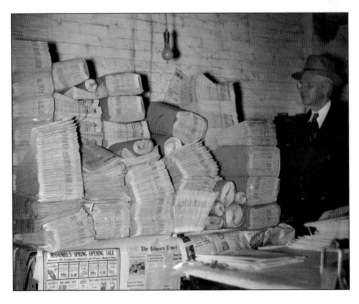

J. Roy McGinty, longtime editor of the *Calhoun Times*, with a career spanning the years 1902 to 1974, was an institution among Georgia journalists. The civic leader also served as a state representative and Calhoun's mayor. Here, in 1941, he checks bundled stacks of the paper awaiting delivery. After the *Cherokee Phoenix*, the first local paper was the *Democratic Platform*, 1855. A publication in 1893 was the *Brobdignagian Yahoo*.

James H. Hobgood, editor and publisher of the *Gordon County News*, and columnist Ginny Reese display awards the paper won from the Georgia Press Association about 1950. Following a widespread trend, the *News* merged with the *Calhoun Times* in 1951, but for many years the two papers still published two separate editions weekly, one under each name. The masthead now displays both titles, with the *Times* being the more prominent.

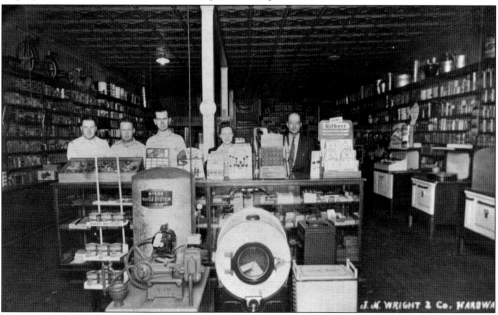

The J.M. Wright & Co. Hardware store on Court Street carried a variety of products from water systems to bicycles, washtubs, and cook stoves. Joe Thomas, from left, Charlie Long, Claude Nichols, Mable Kiker, and Pruitt Nelson minded the store in 1941. Logan Pitts, a cotton factor, had his office in the building with a secretary, Lois Cantrell.

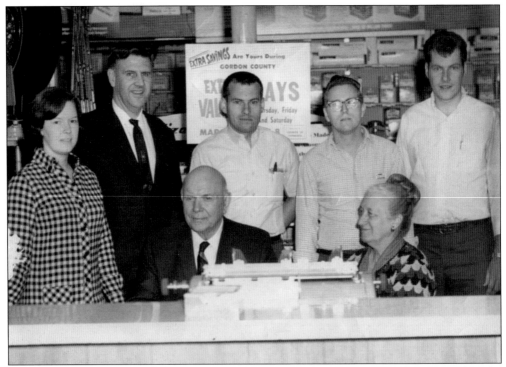

The Western Auto Store on South Wall Street across from the Rooker Hotel was owned in the 1960s by Earl Leach, seated left, and his wife, Louise, to his right, from Cartersville. The store's longtime manager was Emmett Walraven, not pictured. The hardware business sold automobile parts, tires, and television sets. (Courtesy of Patsy Barrett.)

The Calhoun Woman's Club sponsored Industry Appreciation Week and Hats Off to Industry Day in October 1957. Drawing a large crowd and many participants, the day featured, from left to right, (first row) Bert Lance and J. Roy McGinty; (second row) US congressman Henderson Lanham, Sen. Herman Talmadge, and Sen. Richard B. Russell.

Politicians visited Calhoun to chat with voters as well as to salute local industry. At top, in an undated photograph, Georgia House Speaker Roy Harris, second from left, talks with a group of businessmen on South Wall Street. During his political career, Harris was committed to improving public education and maintaining segregation in the state. He served in the legislature from 1933 until defeat in 1946 and remained a powerful figure afterwards. More than four decades later, in 1976, Georgia secretary of state Max Cleland visited the spring meeting of the Gordon County Historical Society at Cedar Hill Lake. Cleland, who lost three limbs during the war in Vietnam, was a US senator and led the Veterans Administration under Pres. Jimmy Carter.

The Calhoun National Bank provided a community room, called the Red Carpet Room, in which it regularly hosted its own and other special events. One such occasion was an exhibit of the art of Herbert Shuptrine that opened with a special reception on December 7, 1968. Above, Gladys Powers (left) and Sara Muse admire one of the works. At a stockholders' luncheon and meeting in February 1972 are, from left to right, Alice Rose McAfee, S.B. Powers, Frank Walraven, and Kayanne Walraven.

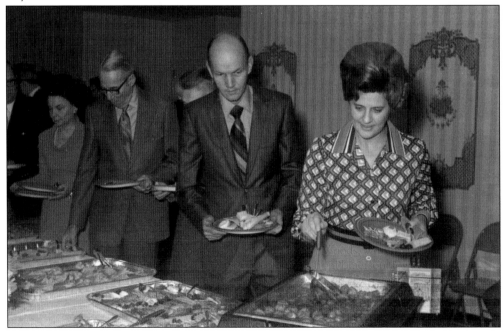

Seven

ALL AROUND THE TOWN

A walk around Calhoun in the 19th and 20th centuries yielded a healthy mix of recent and old—old in this case meaning since the middle of the 1800s. Gen. William T. Sherman and his troops took care of the older sites, with the exception of a few houses. Because all northwest Georgia had been within Cherokee territory until a few years before the Civil War, Calhoun was a small village from its founding in 1852 until Federal troops visited in 1864. Then it became smaller, for a time.

When W. Laurens Hillhouse built many of Calhoun's homes and public buildings, he used local materials: wood, brick from silty, muddy soil, and an unusual rock called Ordovician Phase limestone, known locally as Knox formation chert. It was formed about 480 million years ago from some of the oldest seabeds in the world and therefore includes small marine fossils such as grasses, mosses, and small shells.

Archaeologist James B. Langford, in describing Knox formation chert, says that it can be found in only four states, including Georgia. In this state, it is found only in parts of Gordon, Bartow, Floyd, and Polk Counties, with small pockets in Murray and Whitfield Counties. Native Americans used it occasionally for making points, although its hard, rough edges and many fractures make it generally unsuitable for tools. Most of Hillhouse's work has fallen to time and progress, but the distinctive rockwork is visible in older parts of town.

Calhoun once was known as a city of trees and fountains. These, too, have fallen through the years. The town's main thoroughfare, US 41, or Wall Street, was once lined with white oak trees that met over the street. Those trees disappeared when the highway was widened. The old fountains that graced the city are lost; now, only two streams cascade from recent brick structures—one in a new city park and the other in front of the courthouse.

A look at the following photographs will reveal buildings, trees, fountains, and people, many now gone, but, thanks to the photographer's lens, not forgotten.

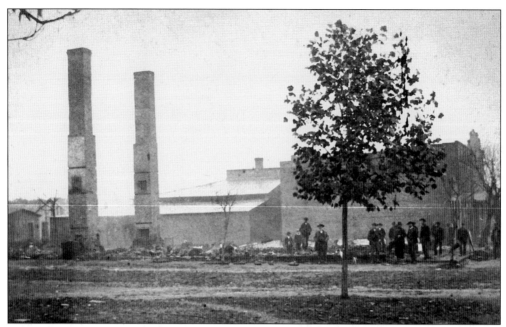

Gordon County's first courthouse, built in 1851, occupied the same downtown Calhoun block that the present one does. Though official documents were removed during the Civil War in an effort to save them, Federal troops occupied so much of the town that many records were destroyed despite the town's efforts. A cyclone that blew through town in 1888 and subsequent fires ruined the original building (above) as well as many businesses. Court sessions moved among several business houses while a new courthouse was constructed. It is thought that the chimneys from the first courthouse were incorporated into the replacement, completed in 1889. William Dowling of Chattanooga contracted to build the structure for $16,000. The foreman of the brickyard on the Sugar Valley road, W.L. Hillhouse, worked on the courthouse and supplied construction materials.

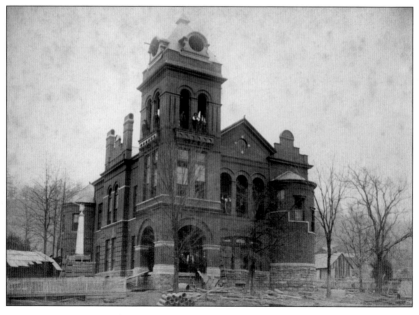

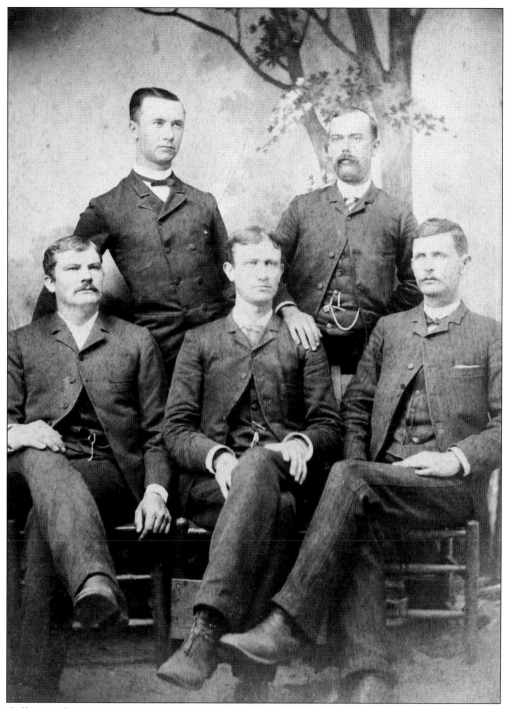

Calhoun's first city council members, in 1852, were called commissioners. By 1854, they were led by an elected mayor, briefly called a marshal. The mayor's salary in 1871 was $100. In this 1889 photograph, the council members are, from left to right, (seated) W.M. Hughey, Logan Robert Pitts, and W.D. Fain; (standing) the chairman, James A. Hall and O.C. Ingram. (Courtesy of VG gor470.)

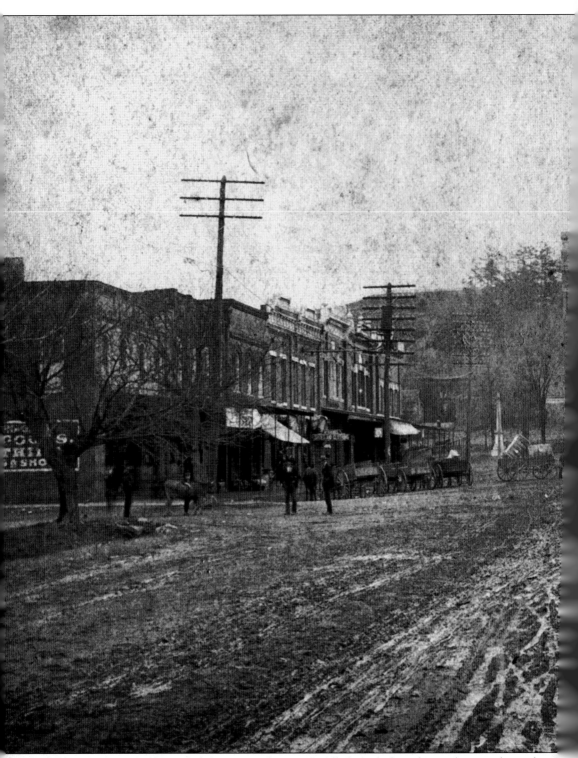

Melting snow or rain revealed the unpaved streets in all their slush and ooze, here in the mid-1890s. A saloon had been in one of the stores to the left, and the tall building to the right is the

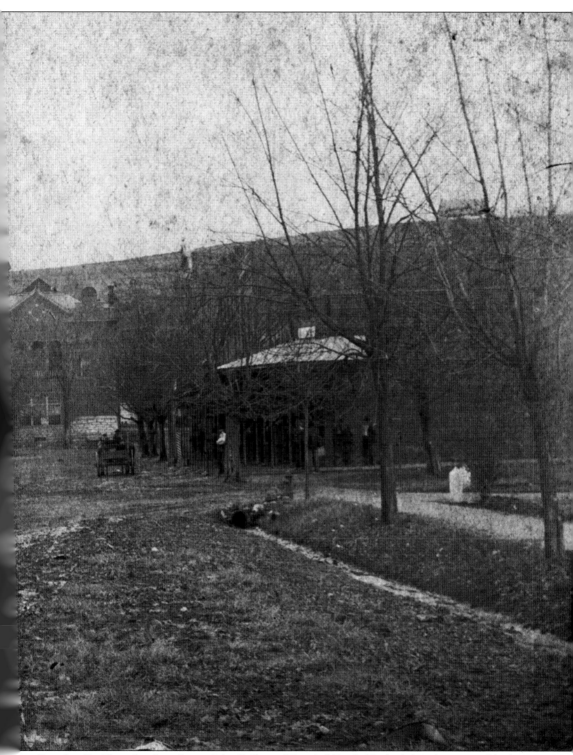

Doughty Building that later housed the Calhoun National Bank. To the left, a discouraged-looking cow contemplates the mess.

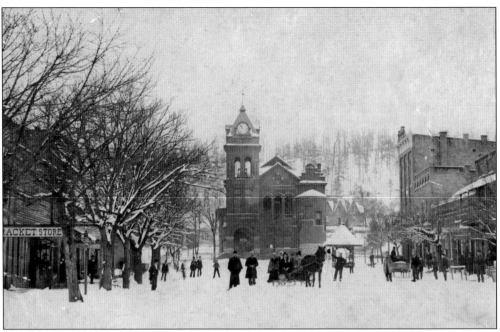

A favorite Calhoun photograph captures the old courthouse in the snow of 1892. Underneath the white blanket, Court Street and the sidewalks are unpaved. Waving his hat, a man stands in front of the public well. There are several opinions about the identities of the people in the street, but nothing is definitive.

A frozen fountain in Gentlemen's Park is the site of a gathering during an ice and snow storm in the winter of 1904. To aid the war effort, the fountain was melted down during World War II, and the park was converted to a parking lot. Beautiful Calhoun's sparkling fountains, lauded in 1916 by poet Ernest Neal, are now reduced to two modern brick structures.

A drinking fountain at Bull Neck on South Wall Street is partially surrounded by a wall to protect it from the animals that freely used the unpaved streets in 1908. At the time, some of the ladies of Calhoun avoided the area around the fountain because it was said to be unsafe, probably due to nearby saloons. Such public water supplies were used both for drinking and for fire protection.

This rock fountain is under construction in Ladies' Park in 1908, following that of the fountain in the Gentlemen's Park. In the background is the Woman's Club clubhouse, called "the Cabin." It became the site of Calhoun's first public library. The fountain was demolished in 1976 to make way for a statue of Sequoyah in Bicentennial Park. That statue, too, had a fountain at its base, which is now a flower bed.

A now-completed fountain in the Ladies' Park is the subject of a postcard in the 1920s. The cabin and park have been landscaped and a rock bench added beside the path. Built by W.L. Hillhouse in 1910, the fountain was razed in 1976. The cabin made way for a new Calhoun–Gordon County Library building in the 1960s.

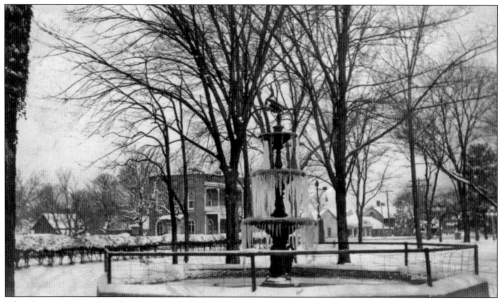

The fountain in Gentlemen's Park became even more picturesque when it froze in a storm in 1929. In the background across the railroad tracks, the Haynes House hotel, also known as Logan Hotel and Rankin Hotel, stands ready for alighting rail passengers.

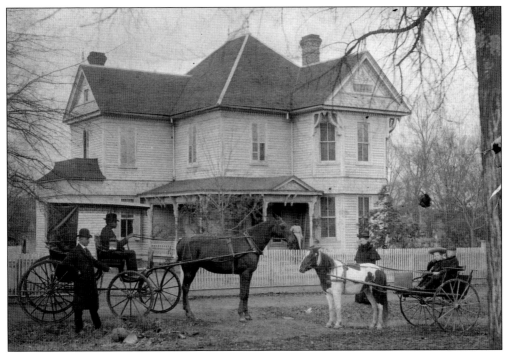

The T.W. Harbin family lived in this house on North Wall Street in 1903, when the photograph was taken. Built by D. Howard Livermore, first president of the Calhoun National Bank, the house went to the Harbins and then to Judge J.H. Paschall and his wife, Milda Harbin Paschall, here riding in the pony cart. The house was razed in the late 1950s to make way for a bank building.

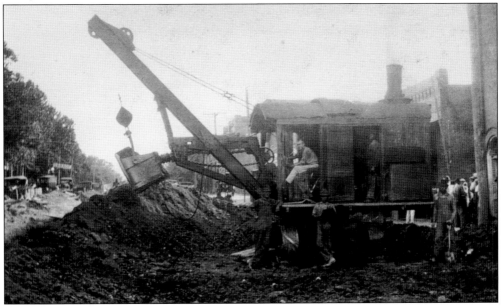

The streets of Calhoun were paved in 1918–1919. This view faces east toward the courthouse, with the three-story Doughty Building to the right. Before street paving, buggies and automobiles parked on a diagonal in the center of the street, where, after a heavy rain, they were forced to remain until the muddy street dried enough for them to move away.

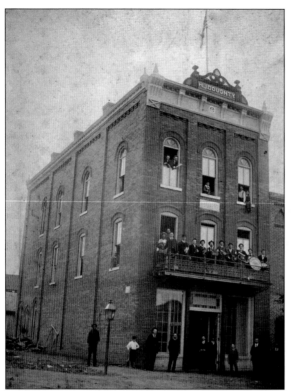

The Calhoun Cornet Band stands on the balcony of the Doughty Building, constructed by W.L. Hillhouse in downtown Calhoun in 1892. The structure was part of a rebuilding effort following the devastating storm and fire of 1888 that destroyed several businesses. Some of Hillhouse's building efforts, many faced with a distinctive local rock, may be found today in Calhoun.

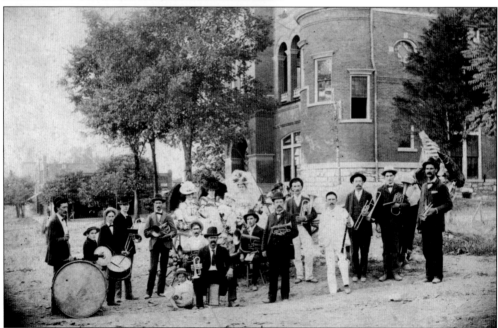

Accompanied by festively attired women in a horse-drawn buggy decked in bunting, the Silver Cornet Band stands to the side of the Gordon County courthouse on July 4, 1898. The buildings to the rear, facing south, front on North Court Street with North Wall Street to the left. The courthouse was demolished in 1961 to make way for a more modern building.

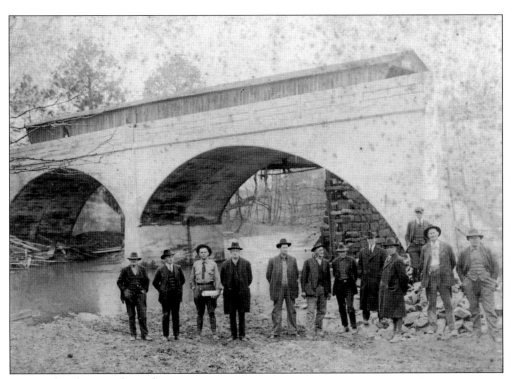

Not much is known about this image, reportedly made in the 1920s at Oothcaloga Creek. A new bridge, with framing and construction rubble lying on the creek bank, has replaced an old wooden covered bridge in the background. A note says only that the bridge was built by Conroy Pickering. Workers completed a steel-framed railroad bridge in the early 1900s, displaying a construction method between that of the wooden covered bridge and the later concrete span. The man atop the pole to the left seems to be hoisting a flag to celebrate the job's completion.

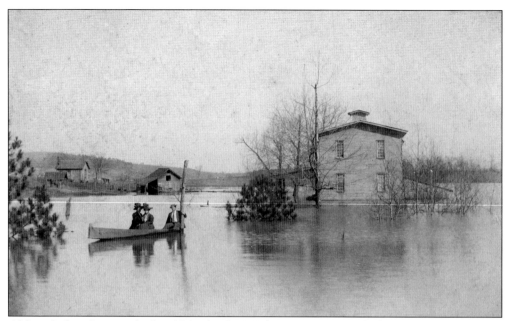

Although this photograph, dated March 15, 1909, has a notation on the back that says the scene is the Oostanaula River flooding near the Calhoun Water Mill, the location appears to be Logan's Mill on Oothcaloga Creek. In the canoe, dressed for the occasion, are, from left to right, Mary Addington, Mary Bolding, and Charles E. ?

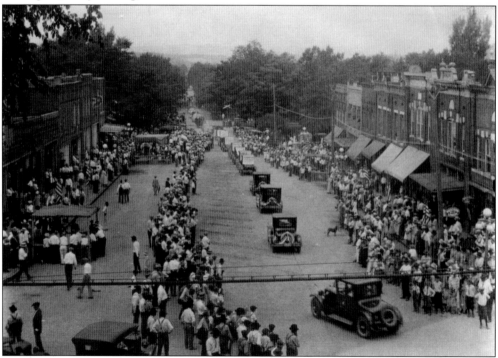

Decorated cars head west on Court Street in 1926. Flags line the sidewalks, but the purpose of the booths on the left has not been determined. This image was taken from a balcony high on the courthouse facade.

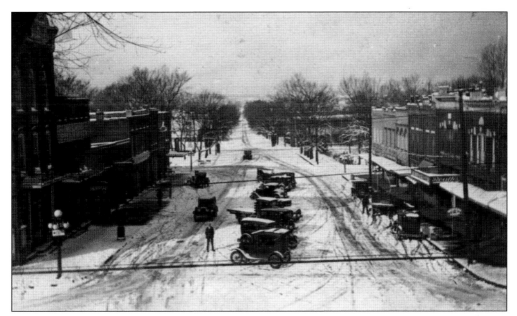

Taken in December 1929, a photograph shot with a westward view from the top of the courthouse shows the traditional practice of parking diagonally in the center of the street. Cars stuck in the snow either had to be pushed or were forced to wait for a thaw before they could be moved.

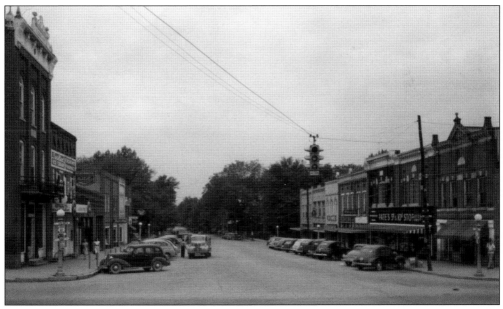

By 1949, the view from the courthouse looking west on Court Street had changed substantially. Cars parked at angles facing the curb, and the center-street parking had disappeared. Storefronts display names of new businesses, including Pate's 5¢ and 10¢ Store. By that time, a signal light had been installed to control traffic at Wall Street.

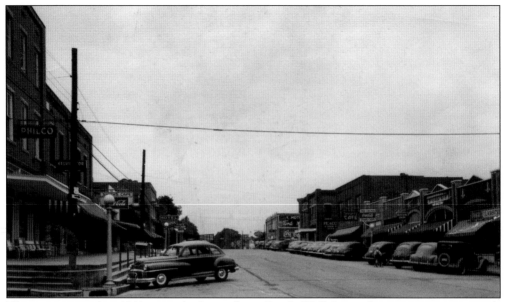

The view in another 1949 image looks south on South Wall Street from its intersection with South Court Street. On the right are Robertson's Department Store, A&P grocery, Western Union, Offutts Café, Fox Ford building, the Peacock Hotel, and an Amoco gasoline station; to the left stand L. Moss Music Company, Smith's Café, and the Hotel Rooker. The east (left) side of the street was raised during construction for the Dixie Highway.

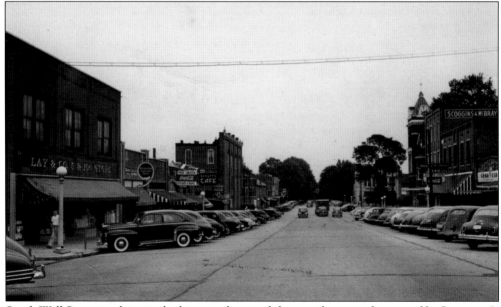

South Wall Street, in this view looking north toward the courthouse, is dominated by Scoggins & McBrayer Furniture Company and Lay & Co. 5¢ & 10¢ Store. Although the east side of the street was raised when the Dixie Highway was built, the west side stayed level with the sidewalks.

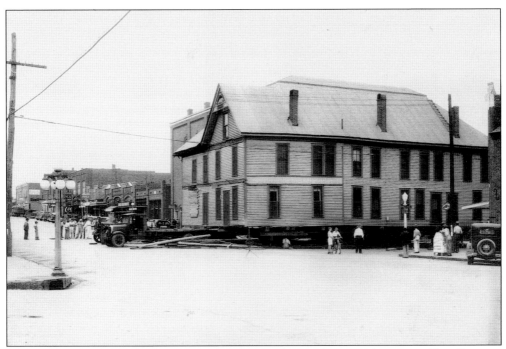

The relocation in the early 1930s of the Hotel Rooker from its long-standing site on King Street to South Wall Street (above) attracted spectators as it made the right-angle turn from Court Street to South Wall. Built by the Rooker family in 1906, the clapboard hotel attracted drummers, or salesmen, because it conveniently stood beside the railroad tracks. A brick facade was added to the structure in 1935. After sitting vacant for several years, the building was bought by the Calhoun Gordon Arts Council to be the home of the Harris Arts Center. Incorporating the Roland Hayes Museum, visual art galleries, Calhoun Little Theater, Calhoun Community Chorus, music guild, and studios, the arts center adds to the vitality of downtown Calhoun.

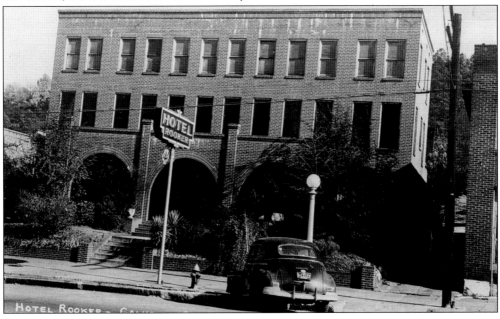

Builder W. Laurens Hillhouse and his niece Esther Love stand on the steps in front of his house on Trammell Street in the 1930s. Hillhouse was known for the distinctive rockwork evident in the background of this image. He was mayor for seven terms, built many public and private structures in the city, and even served for two years in Presbyterian mission work to the Belgian Congo in the early years of the 20th century. An earlier photograph, below, shows the Hillhouse family about 1892 at their home on North Wall Street. Hillhouse notes on the back of the image that he built the house in 1888. He is sitting in the rocking chair to the right. (Below, courtesy of the City of Calhoun.)

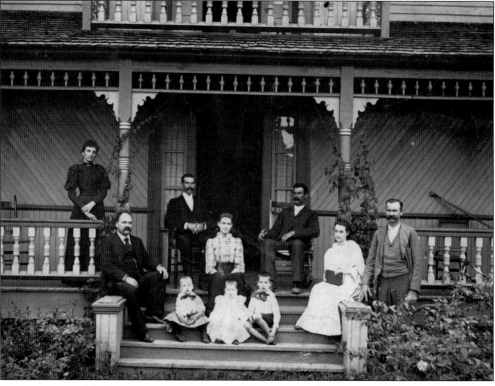

Calhoun and Gordon County were dry until recently, but that did not keep some people from enjoying a nip on occasion. Town residents knew where to find moonshine stills in the county, and so, apparently, did the sheriff and his crew. Jim Owens, Will Shirley, and Grady Moore, from left to right, protect a confiscated still in front of the jail on Piedmont Street about 1934, sending a warning to moonshiners and imbibers alike. (Courtesy of VG gor030.)

A group of unidentified children enjoys a birthday party on Alexander Street in the 1940s. Birthday celebrations at the time were simple affairs with games like Pin the Tail on the Donkey, musical chairs, and London Bridge Is Falling Down. Cake and ice cream were standard, often the only fare. (Courtesy of VG gor482.)

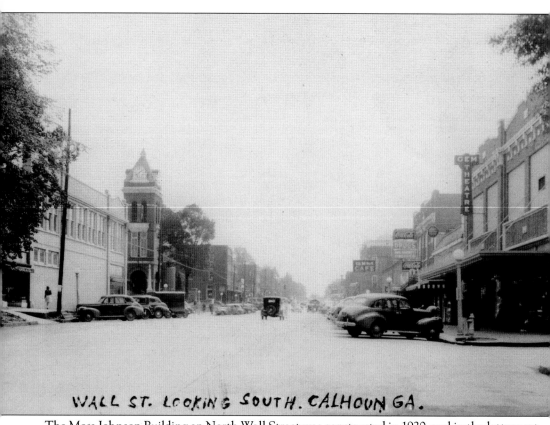

WALL ST. LOOKING SOUTH. CALHOUN GA.

The Moss-Johnson Building on North Wall Street was constructed in 1920, and in the latter part of that decade became the Gem Theatre, which showed first-run movies. Its cowboys-and-Indians features entertained generations of Calhoun children on Saturday mornings, and occasionally B-grade cowboy stars performed at the theater. An earlier movie house had shown a film in early 1919 to celebrate the end of World War I in November the year before. Martin Theater chain acquired the business but left downtown in the 1970s. After the building was vacant for more than 20 years, Pearl and Raymond King purchased the long-neglected structure and donated it to Friends of the GEM. Following years of fund-raising it underwent an award-winning renovation before opening in 2011. The theater has enjoyed a revival as a downtown entertainment venue. In this image from about 1941, the GEM is to the right, with a canopy but without the now-familiar marquee. Beyond it, the Fincher Drug Company and Gem Café can be seen to the south. (Courtesy of Lee and Bob Linn.)

The Calhoun Quarterback Club organized to support activities of the Yellow Jacket football team of Calhoun High School. Besides cheering on the teams, club members held fundraisers for uniforms and treated players and their dates to an annual banquet that celebrated real or anticipated winning seasons. Phil Reeve was credited with revitalizing the club in 1948. Here, club members meet in 1974 to plan their year. (Courtesy of VG gor152.)

Three urchins, neighbors, and best friends stopped their play long enough for Gus Boaz to photograph them in 1939. All three went on to play football, graduate from Calhoun High School, go away to school, end their careers in their native city, and remain fast friends. They are, from left to right, Jimmy Lay, Teddy Collins, and Robin Collins.

The old J.M. Kay house on South Wall Street was demolished in 1986 to make way for a new chamber of commerce. The Kay house, built in 1850, was one of Calhoun's few antebellum homes and had slave quarters behind the house. In the left photograph, chamber president Phil Overton holds a photograph of the old house while standing with Bill Kay (center) and board chair Ron Dobbs on the steps of the new chamber headquarters. Back in 1925, Kay's father-in-law, J.M. Kay, stares down the camera in the backyard, standing next to the cabin and a flock of chickens.

Two prominent women clown around on the railroad tracks near the depot, probably in the 1960s. Minnie David, left, talented musician and wife of banker Tom B. David, and Myrtle McGinty, clubwoman and wife of *Calhoun Times* editor J. Roy McGinty, play hobo right in the middle of town.

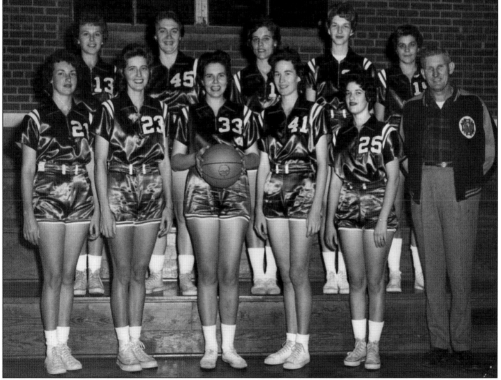

The Veterans of Foreign Wars sponsored traveling basketball teams for women. This group from the 1960s, all mothers of young children, played not only in Georgia but as far away as Tennessee, Alabama, and Florida. The coach was James Hollaran (pictured in the first row). (Courtesy of Helen Jane McDonald.)

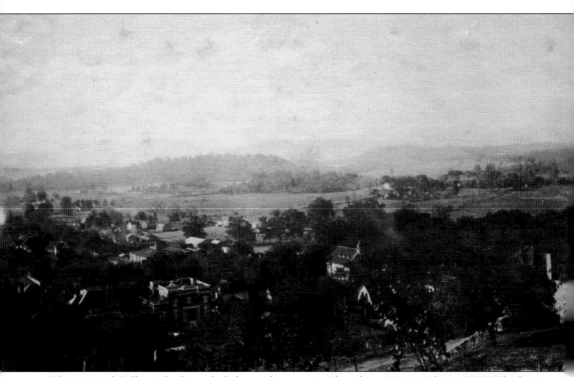

This view of Calhoun looking slightly northwest was taken from Mount Alto in 1918. The large brick-and-marble structure at front left is the Piedmont Street back entrance of the new Methodist Episcopal Church, South, dedicated in 1917. The steeple of the First Baptist Church rises to the right. Built in 1889 and remodeled in 1909, it was razed in 1921. To the left of the Methodist church is the Dr. Roy Richards house, built in 1910. At the foot of the hills on the horizon is the valley formed by the Oostanaula River and Oothcaloga Creek.

Fire Chief Henry Lay Sr. (1893–1955) headed Calhoun's fire department from 1938 until 1945. Here, he and his younger son, Jimmy, try out the city's 1921 LaFrance fire truck in 1938. Calhoun's combined fire hall and city hall were dedicated on May 29, 1939, when James H. Reeve was mayor. In 1975, the city hall moved to the old post office on North Wall Street, at right, and this building became the location of municipal court. The fire truck ended up in the hands of a college fraternity in Chattanooga.

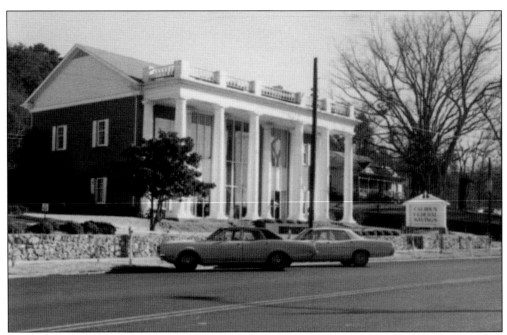

Calhoun's city hall moved yet again when it outgrew the building on North Wall Street. The city found larger quarters a block from the courthouse on South Wall Street, in a building that had first been Calhoun Federal Savings. The grounds of the old Kay house in the background became the site of the Gordon County Chamber of Commerce.

Preston Aker Sr., wearing his police uniform, holds his son Preston Jr. in 1960, the year the senior Preston was hired as the first African American member of the Calhoun police force. (Courtesy of Janie Aker.)

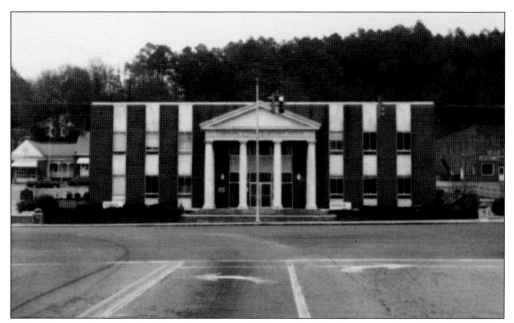

After the courthouse depicted on the cover and in several other images was demolished in 1961, a new building rose on the same grounds, facing west, just as the others have. Since this photograph was taken in 1974, an added story has expanded court and office space. General Nelson's cenotaph, visible in some early images, was returned to the courthouse grounds in 2013.

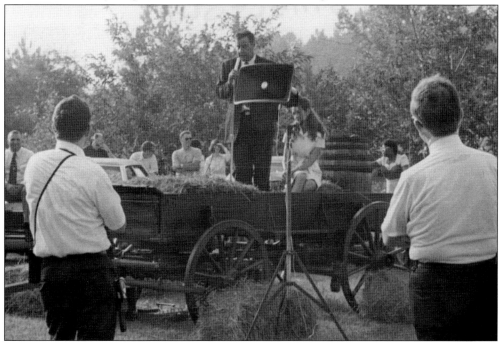

Bert Lance announces his gubernatorial campaign in 1974. The popular Calhoun banker served as director of the Georgia Department of Transportation under Gov. Jimmy Carter and later went to Washington to head the Office of Management and Budget during Carter's presidency. His wife, LaBelle David Lance, sits behind him.

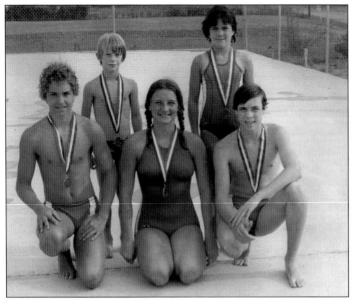

The Blue Barracudas, swimmers from the Calhoun Recreation Department, teamed with the Rome Y team in Y-league competition for several years. Young medal winners in the mid-1970s proudly display their awards. Edna Langford founded Calhoun's swimming program and was a popular instructor for many years. She began teaching in the late 1940s at the old Elks Club pool, spring-fed and made of rough concrete. (Courtesy of Helen Jane McDonald.)

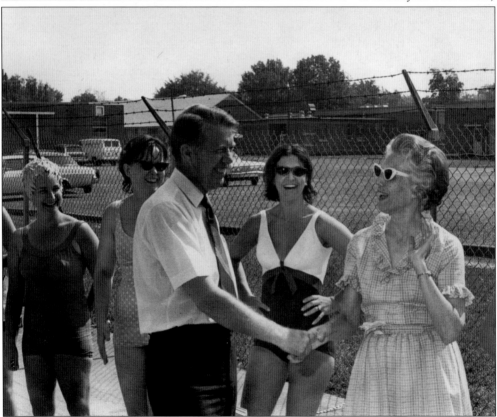

Jimmy Carter visits the pool at the Calhoun Recreation Department in the early 1970s, either during or shortly after his successful campaign for governor. Here, he is greeted by Gladys Powers as, from left to right, Glo Hobgood, an unidentified instructor, and Judy Langford, who married his son Jack, look on.

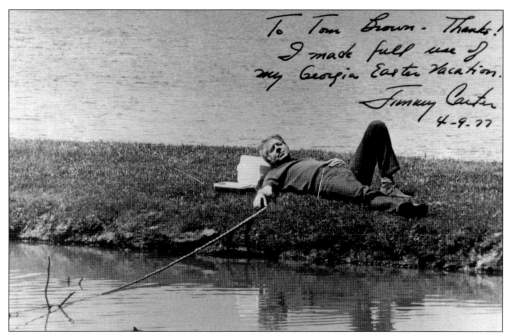

To Tom Brown – Thanks!
I made full use of
my Georgia Easter Vacation.
Jimmy Carter
4-9-77

Jimmy Carter's good friend Bert Lance was a Calhoun banker when Governor Carter appointed him head of the Georgia Department of Transportation and later director of the US Office of Management and Budget. Here, President Carter enjoys fishing and mostly relaxing on the bank of Cedar Hill Lake at the Brown farm near Calhoun.

Lulie Pitts (1865–1948), widely known then and now as "Miss Lulie," was Calhoun and Gordon County's first historian. The Calhoun Times published her *History of Gordon County, Georgia,* in 1933. Educated in the city's public schools, at Cox College in LaGrange, and at other institutions, she was an educator and a civic and church leader whom the grand jury named official historian in 1931.

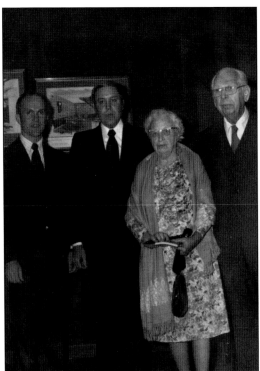

Gordon County Historical Society officers in 1977 are, from left to right, Jim Lay (treasurer), John M. Brown (vice president), Jewell Reeve Alverson (president), and Burton J. Bell (secretary). Lay went on to be longtime president of the society; Brown collected many of the historic images used in this volume; Alverson, a musician, published informal histories of the county; and Bell compiled the *Bicentennial History of Gordon County, Georgia, 1976*.

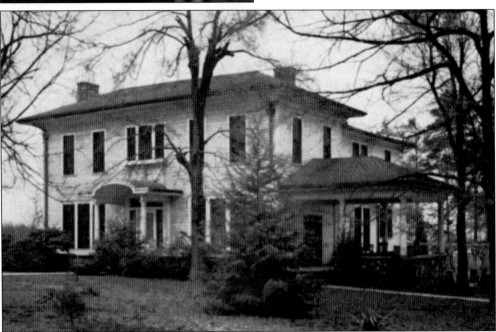

Oakleigh, home of the Gordon County Historical Society, was standing on South Wall Street when Union troops marched by in 1864. Shortly after the society incorporated in 1974, it purchased the historic house for its headquarters. For many years, a wing housed more than 2,000 dolls donated by Minnie Roe. The society now exhibits a small, representative group of the dolls in a museum room.

BIBLIOGRAPHY

Bartley, Numan G. *The Creation of Modern Georgia*. Athens: University of Georgia Press, 1983.

Bell, Burton J., ed. *1976 Bicentennial History of Gordon County, Georgia*. Calhoun, GA: Gordon County Historical Society, 1976.

Brown, John M. *Yesteryears: Pictorial History of Calhoun and Gordon County, Georgia, 1830–1977*. Calhoun, GA: Gordon County Historical Society, 1977.

Coleman, Kenneth. *A History of Georgia*. Athens: University of Georgia Press, 1977.

Deaton, Thomas M. *Bedspreads to Broadloom*. Chattanooga, TN: Color Wheel, 1993.

Edwards, Leslie, et al. *The Natural Communities of Georgia*. Athens: University of Georgia Press, 2013.

Georgia Humanities Council. *The New Georgia Guide*. Athens: University of Georgia Press, 1996.

Henderson, Sue, et al. *Gordon County, Georgia, Cemetery Records*. Calhoun, GA: Gordon County Historical Society, 1988.

Knapp, Oliver A., Jr. *Chief Kisco and His Brothers*. Mount Kisco, NY: Mount Kisco Historical Committee, 1980.

Malone, Henry. *Cherokees of the Old South*. Athens: University of Georgia Press, 1966.

New Echota issue. *Early Georgia* 1, no. 4 (Spring 1955).

New Georgia Encyclopedia. georgiaencyclopedia.org.

Pitts, Lulie. *History of Gordon County, Georgia*. Calhoun, GA: Calhoun Times, 1933.

Reeve, Jewell B. *Climb the Hills of Gordon*. Calhoun, GA: self-published, 1962.

Zainaldin, Jamil. "Jamil's Georgia." saportareport.com.

DISCOVER THOUSANDS OF LOCAL HISTORY BOOKS FEATURING MILLIONS OF VINTAGE IMAGES

Arcadia Publishing, the leading local history publisher in the United States, is committed to making history accessible and meaningful through publishing books that celebrate and preserve the heritage of America's people and places.

Find more books like this at
www.arcadiapublishing.com

Search for your hometown history, your old stomping grounds, and even your favorite sports team.